Claude Monet

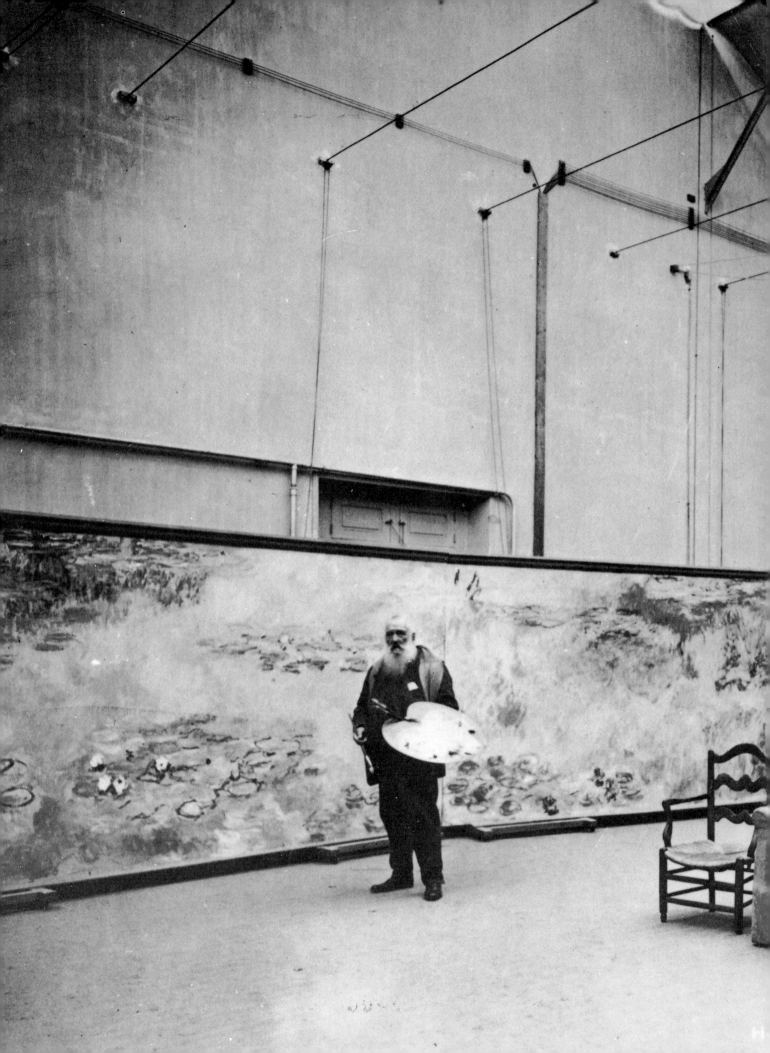

Claude Monet

THE FIRST OF THE IMPRESSIONISTS

Brian Petrie

Phaidon · Oxford

Phaidon Press Limited, Littlegate House,
St Ebbe's Street, Oxford

First published 1979
Published in the United States of America
by E. P. Dutton, New York
© 1979 Phaidon Press Limited
All rights reserved

ISBN 0 7148 1968 9
Library of Congress Catalog Card Number: 78-73432

Printed in Great Britain by Waterlow (Dunstable) Ltd

1 (frontispiece). Photograph of Monet in the large studio
specially created for working on the *Water-Lilies*. About
1920. Collection Durand-Ruel.

List of Plates

Select Bibliography

The interested reader and the student in search of further reading on Monet will turn naturally to John Rewald's monumental *History of Impressionism* (4th ed., New York, 1973), with its extensive bibliography. I should like, however, to record my particular indebtedness to the following works, without which this essay could not have been written:

Gustave Geffroy, *Claude Monet, sa Vie, son Temps, son Oeuvre*, Paris 1922

Jean-Pierre Hoschedé, *Claude Monet ce Mal Connu* (two volumes), Geneva 1960

Joel Isaacson, *Monet: Le Déjeuner sur l'Herbe*, London 1972

Steven Z. Levine, *Monet and his Critics*, New York and London 1976

Lionello Venturi, *Les Archives de l'Impressionnisme*, Paris 1939

Daniel Wildenstein, *Claude Monet: Biographie et Catalogue Raisonné* (Volume 1: Paintings 1840-1881), Lausanne and Paris 1974

Claude Monet

On 15 April 1874, a fortnight before the opening of the official Salon, a dissident exhibition opened in the former studios of the photographer Nadar, at 35 Boulevard des Capucines, in the centre of Paris. Thirty artists participated in this first manifestation of the co-operative *Société Anonyme de Peintres, Sculpteurs, Graveurs etc.*, most of whom, including Oscar-Claude Monet, had in former years exhibited at the Salon. But to submit work to the Salon jury was to run the risk of rejection. After an initial success, when both his submissions were hung in 1865—a promising and well-received entry to his professional career which was repeated in 1866—Monet had only one work accepted in 1868. In 1867, 1869 and 1870 he was rejected outright. But even if a work was accepted and well hung, what chance had it of being noticed among the huge number of exhibits? In 1872, 2,067 items figured in the catalogue, in 1880 there were 6,743. The *Société Anonyme*, in whose organization Monet had played a major part, might draw much smaller crowds, but its exhibitions offered the spectator a better opportunity to appreciate—or to mock—the exhibits.

The exhibitors at the *Société Anonyme* did not form a coherent group. They represented no clear artistic tendency. But a somewhat factitious unity was to emerge from their exhibition, for one of Monet's nine exhibits became notorious. The title of his *Impression, Sunrise* (Plate 39) had been chosen with no directive ambition, but it gave rise to the term *Impressionism*, by which the subsequent exhibitions of the various participants came derisively to be known. The term *impression* was current in the critical language of the time to denote a rapid and sketch-like treatment, a first, intuitive response to a motif understood to be subject to later elaboration. Such a title could therefore be recognized by any informed observer (a category of persons that did not include all the critics) as disclaiming any excessive ambition, and least of all as proposing a new aesthetic norm. A new manner, which was to impose itself increasingly over the next decades, was indeed visible in some of Monet's other contributions to the exhibition of 1874, but his caution was instanced by his inclusion of the large *The Luncheon* (Plate 2), which he had thought suitable for submission to the Salon of 1870. It had been rejected by a jury which no doubt found its bold handling of paint deficient in professional finesse, but after the achievements of Courbet, and of Manet, this was no longer a revolutionary, though it could be seen as a radical, painting.

The more advanced artists of the time generally thought of themselves as 'Naturalists'. The Impressionists themselves sometimes preferred the even less specific term 'Independents'. But the label 'Impressionist' imposed itself so quickly and so definitively that we now find no

7

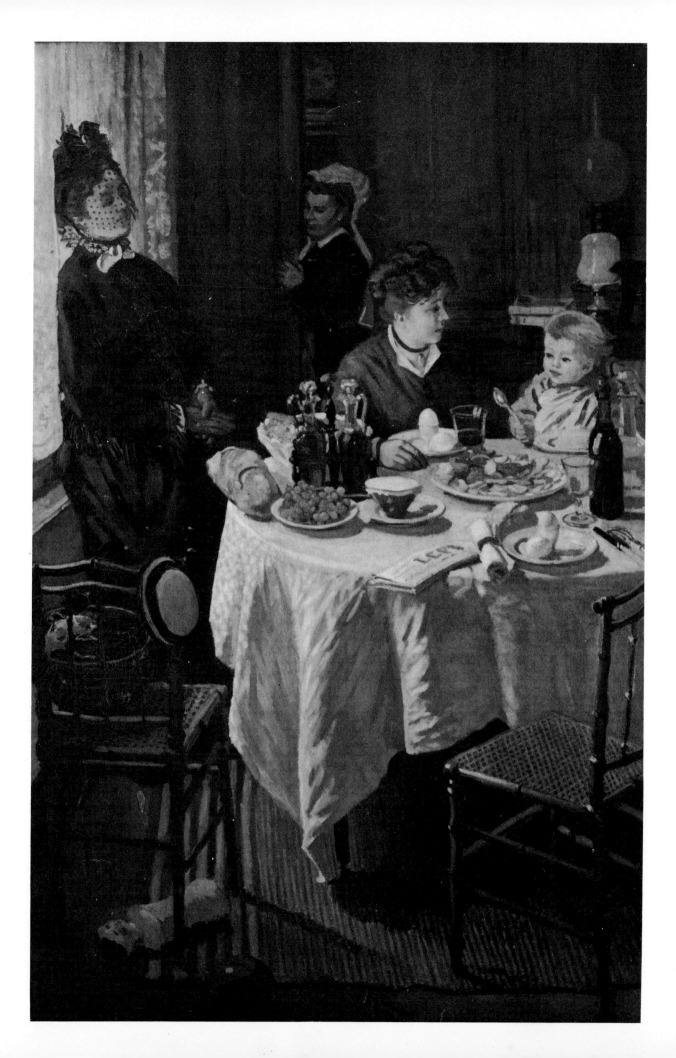

difficulty in applying it to some of Monet's co-exhibitors of 1874: to Armand Guillaumin, Berthe Morisot, Pissarro, Renoir, Sisley and, though only tangentially, Cézanne. When a second group exhibition was held in 1876 the contributors numbered only eighteen, and though there was still no real sense of stylistic unity, Monet's pre-eminence among his colleagues began to be recognized. In a pamphlet of 1878 called *Les Peintres Impressionnistes*, Théodore Duret found Monet to be 'the Impressionist *par excellence*'. Earlier in the decade the artistic radicalism that Monet and his friends were seen to represent had been laid at Manet's door, but when Manet exhibited at the official Salon in 1875 one critic found him 'timid, in his effects, by comparison with Claude Monet'. Monet had indeed exerted some influence on the older man; the two had worked together at Argenteuil, where Manet's Salon piece had been painted. If *The Luncheon* had been evidently indebted to Manet's approach, Manet reciprocated with the intensity of his colouring and the delicacy with which his brush responded to each nuance perceived in nature.

Impression, Sunrise is not a typical Impressionist painting precisely because its true purpose was ambivalent. It did not succeed in reconciling the conflicting claims of a naturalism confronted by the morning mists in the harbour at Le Havre and the evident adherence to the 'sketch' or 'impression' procedure. The sun's reflection, in particular, is handled with a brevity which falls well below the degree of finish attained by the painter in his more truly Impressionist works. Impressionism continued to incur criticism on the ground that it lacked finish, but this was because few could distin-

guish between the traditional and the new implications of this ideal, a problem of communication that continued to trouble Monet for the next twenty-five years. Whatever Monet's precise intentions in painting and exhibiting this work—to display sensitivity to an effect rather than fully to record it, to stress a distinction between capturing such an effect and representing a scene—it shows a distinct affinity with some of Whistler's *Nocturnes*, which he may have seen while staying in London in 1870–71. Certainly there is here the feeling of a translation of sensation into meditative reflection, of poetic indulgence, which anticipates the Monet who in the nineties entered a final maturity which was no longer Impressionist.

A view of the *Boulevard des Capucines* (Plate 35), probably painted from the very rooms where the 1874 exhibition was held and where the painting itself was exhibited, is far more representative of Monet's Impressionism in the seventies. Like its companion (Plate 34), it is of modest size, suitable for hanging in a Parisian apartment, a scale only increased at all frequently much later, when the painter was able to afford more materials. In both these paintings he adopted a 'natural' view, as if in a photograph, thus implicitly discrediting the academic value of 'composition'. Some of his later paintings have been felt to show a sense of 'design'; but this was always a *found* design (see Plate 3), rather than something arbitrarily invented. In the case of these views of the *Boulevard des Capucines* such planning as exists concerns above all the choice of horizontal and vertical format respectively, and the reasons for such choice seem evident when considered in a strictly naturalist context. Both were painted late in 1873—not at carnival time, as the joyous palette in one case and the balloons displayed by a vendor in both cases have led some to suggest, but shortly before Christmas. On one of these occasions the

2. *The Luncheon*. 1868. Oil on canvas, 230 × 150 cm. (90½ × 59 in.) Frankfurt, Städelsches Kunstinstitut

sky was largely occluded, while on the other the sun, beginning to fall behind Nadar's studios, cast a strong light on the opposite buildings. In the vertical format it was possible to include the sky and thus establish a tonal effect; in the horizontal format the sun is the invisible medium through which colour is brought to a level of maximum intensity.

To speak of colour is to turn attention to the painter's means rather than to the observed phenomenon with which he was concerned, light in its *effect* on colour. In this respect these two paintings, no less than *Impression, Sunrise,* anticipate an aspect of Monet's work which was to reach its fullest expression in the 'series' paintings of the 1890s (see Plates 56 and 57). In those works a single motif, a single subject, was systematically recorded under a variety of different conditions, some more conducive to a tonal, some to a colouristic approach. But already in 1873, and still more later, the idea of 'tone'—as understood by the painters of the Barbizon School and particularly by Corot—had been subordinated to colour, in so far as it was the primary attribute of the artist's palette, as well as an aspect of nature herself.

Another novel characteristic of the two paintings of the Boulevard was their brushwork which suggests rather than defines form. If the lines traced by the branches follow form, they do so in a very rudimentary way, for Monet was more concerned to blend them into an indistinct mass, or to indicate a fragile web subordinate to intense illumination which reduces them either to reflecting surfaces or to vague silhouettes. Elsewhere the reflective roofs of the cabs are recorded by single strokes which are either colourless in the sunless air or

3. *Bordighera.* 1884. Oil on canvas, 64.8 × 81.3 cm. (25½ × 32 in.) Chicago, Art Institute

10

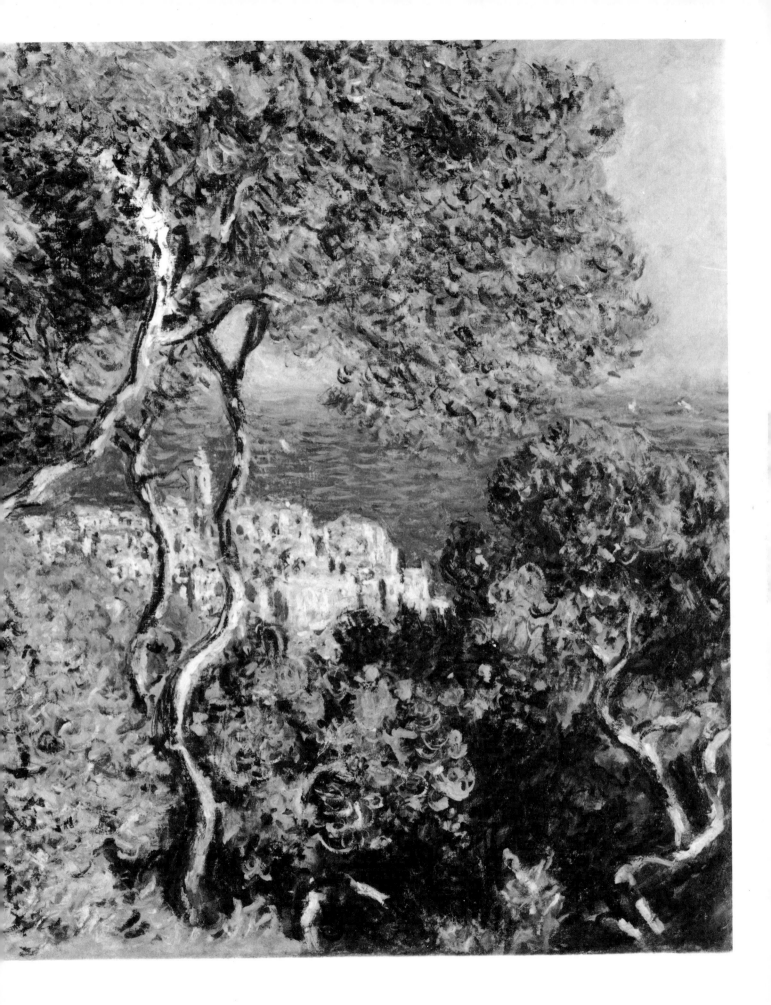

respond to the orange sunlight by assuming a complementary blue. We need not doubt that Monet 'saw' these complementary hues, but it is reasonable to suppose that he had first to be taught to see them by direct or indirect acquaintance with the writings of Eugène Chevreul. They represent the painting of a scientific age. Later, in the hands of the Neo-Impressionists, such contrasts were to become an article of faith and a guide to method. Van Gogh used them in a deliberately expressive and decorative way. But the empirical Monet, who trusted in his own eye before anything else, did not subscribe to them dogmatically.

The hue and formlessness of Monet's brush markings constitute that art of 'effect' which led one critic of the 1874 exhibition to assert that such paintings would be best seen from a building across the street. Another wrote, in a now notorious phrase, of the 'black tongue-lickings' that stood for figures. The vigour of Monet's touch had been recognized by well-disposed critics since the 1860s, but they had then been speaking of works which, however 'painterly', were also far more illustrative than those of the 1870s (compare Plates 9 and 19). These marks, in the most literal sense inchoate, typified the so-called 'lack of finish' to which conservative minds objected. Even a favourable reviewer of the 1874 exhibition considered the *Boulevard des Capucines* to be a mere 'sketch', but he may be thought to have contradicted himself when he praised the work for its unique success in capturing the agitated bustle of the crowd and the 'movement' among the trees. If he considered movement to be at issue, and could enthuse over the marvellous rendition of the 'ungraspable', the 'fugitive' and the 'instantaneity' of the scene, he had little cause to complain of sketchiness.

Monet himself later adopted the word 'instantaneity', but he did so to describe the rapidly changing conditions that enveloped his *Haystacks*: conditions rather than physical

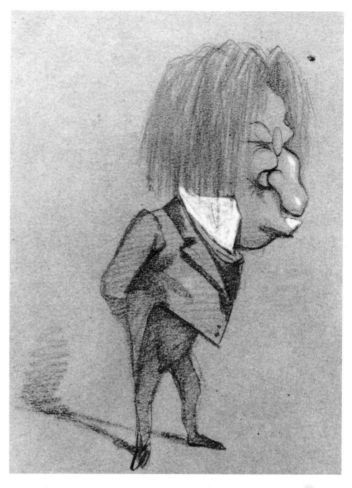

4. *Caricature of Champfleury* (after Nadar). About 1858. Black chalk, heightened with gouache, 32 × 24 cm. (12⅝ × 9½ in.) Paris, Musée Marmottan

movement were what concerned him. Though he may have noticed the shadowy and shapeless after-images produced by the long-exposure photography of the time, it is not necessary to assume the influence of such things (unless he mistakenly thought they gave a better account of the visual *moment* than a fully fixed image). In fact the painter's unspoken principle seems to have been to concentrate on the overview, the totality of the scene, the wholeness wherein the 'effect' resided at the expense of the parts, whether moving or stationary. He was no candidate for appreciation by connoisseurs of the kind who took a magnifying glass to the works of Ernest Meissonier, yet a detail from one of his paintings (Plate 36) shows an astonishing skill

12

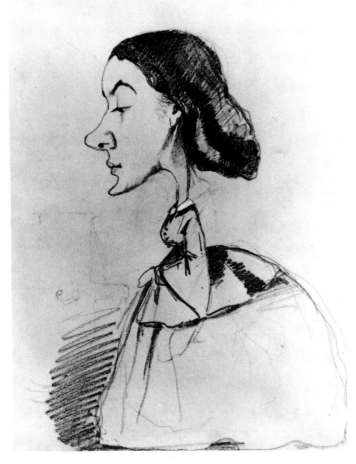

5. *The Pianist*. About 1860. Black chalk, 32 × 24 cm. (12⅝ × 9½ in.) Paris, Musée Marmottan

Some of these were copies: although he may have met Champfleury (Plate 4) in Paris in 1857, this little drawing of the famous critical supporter of the Realist school was a copy after Nadar, who was a painter as well as a photographer. *The Pianist* (Plate 5), in the manner often favoured then as now with an enormous head on a token body, is representative of the independent studies of local personages which he was able to exhibit in the window of a framer's and colour-merchant's shop. One day in 1858, when he was 18, he there met Eugène Boudin, who encouraged him to take up a more serious form of art. That summer the two men, Boudin the older by sixteen years, worked together in the countryside, and Monet first exhibited a landscape at a local exhibition in the autumn. He later frankly acknowledged his great debt to Boudin, who was to participate in the exhibition of 1874. Four years earlier the two had spent part of the summer together at Trouville with their wives. There Monet made several small paintings of ladies, among them his wife Camille, on the beach (Plate 6). Such scenes, of 'crinolines on the beach', were Boudin's stock-in-trade, but Monet may have intended these small paintings to be studies for more ambitious works, such as the large-scale 'paintings of modern life' (Plates 7, 15) which had already aroused Boudin's envy. The problems associated with painting in the open air, to the principle of which Monet was by now almost fanatically addicted, presented certain special hazards: he never worked in watercolour, as his mentor frequently did, and grains of sand have been found adhering to the paint film on the canvas of *The Beach at Trouville*.

Boudin was the first of the two painters largely responsible for Monet's lifelong devotion to confrontation with nature. In 1862 Monet met the Dutch artist Johann Barthold Jongkind near Le Havre. Jongkind offered

and sureness no less apt to capture the Sensation than was a Meissonier to fix the Thing. Monet's retouchings were quite frequent, but they were usually in the interests of completion rather than correction, and seldom extensive.

Oscar-Claude Monet was born in Paris on 14 November 1840. In 1845 the family moved to Le Havre, a city whose maritime role proved crucial in determining the course of his early career, and in whose art school he took the lessons which aroused his interest in the visual arts. There survive some landscape drawings from the mid-1850s which show him to be an adequate copyist, but he first distinguished himself not in landscape but with caricatures which gained him a certain local reputation.

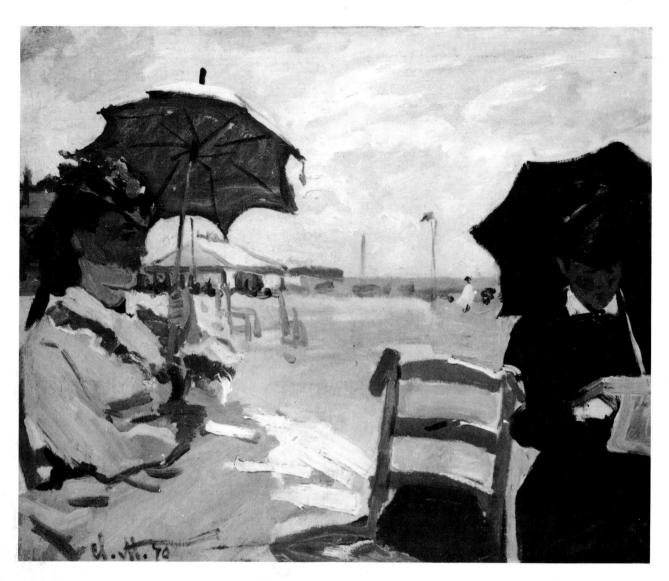

6 (above). *The Beach at Trouville*. 1870. Oil on canvas, 38.1 × 46.4 cm. (15 × 18¼ in.) London, National Gallery

7 (opposite). *Women in the Garden*. 1866. Oil on canvas, 256 × 208 cm. (100¾ × 81⅞ in.) Paris, Louvre, Jeu de Paume

advice and the painters worked together. In 1900 Monet recalled that he owed to Jongkind 'the definitive education of my eye', and by 'eye' he surely meant also the flexibility and spontaneity of the hand in co-ordination with it. Since the early 1850s Jongkind had enjoyed the reputation of being the most interesting marine painter of the time. He employed a technique described by Émile Zola in 1868 as marked by 'astonishing breadth, masterly

simplifications', suggesting 'sketches rapidly brushed, for fear of losing the first impression; one feels that everything occurs in the artist's eye and in his hand . . .' This was not a painter of elaborate artifice, but one who responded almost intuitively to a self-sufficient nature. Also in 1868, Zola referred to Jongkind, Boudin, Manet and Monet as the most distinguished marine painters then working. He praised Monet's sea picture at that year's

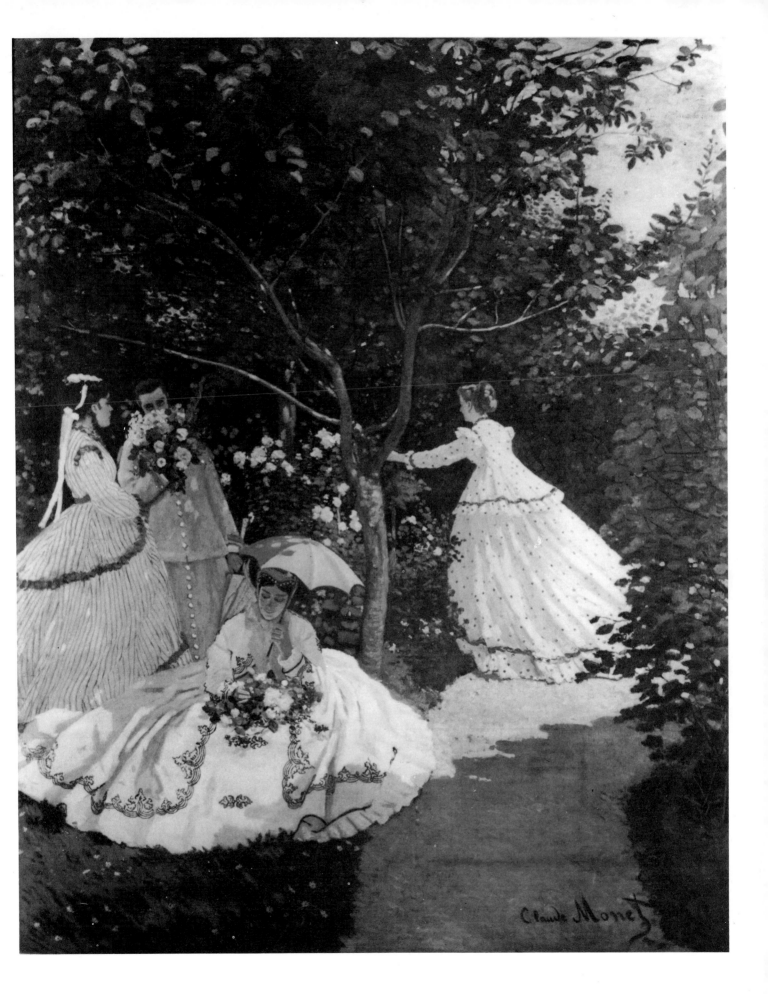

Salon for the freedom and boldness of its touch.

The qualities of freedom and boldness were already present in the two paintings with which Monet had made his début at the Salon of 1865 (Plates 8, 9). Here he showed an ambition which went beyond that of either of his masters and which already foreshadowed later developments, for the two identically sized canvases are composed as if decoratively to balance each other. Each had been anticipated by a smaller painting made the previous year, and Monet's modifications are interesting guides to his intentions at this time. The version of *The Mouth of the Seine* shown at the Salon shows a more agitated sea than does its predecessor, and thus called for more energetic brushwork and greater tonal variation. Maritime activity was now evidently compiled from a number of separate observations and even the profile of the hillside assumed a more dramatic form. This resort to artifice was effective enough to draw the praise of a conservative critic, who noted Monet's 'bold manner of seeing and demanding the spectator's attention'. The 'Raphael of the waters', as Manet later called him, was not at this time quite aloof from the picturesque.

In the case of the *Pointe de la Hève* the main alteration between 1864 and 1865 was to

8. *The Mouth of the Seine at Honfleur*. 1865.
Oil on canvas, 90.2 × 150 cm. (35½ × 59 in.) Los Angeles, Norton Simon Foundation

16

extend the foreground, revealing an expanse of damp and reflective grey sand that reaches the width of the canvas. In this way the painting was given a firm tonal foundation, which recalls, though to very different effect, the observation of Jacques-Louis David (whose pupil Ochard had given Monet his first drawing lessons): 'It is the greys that make painting.' In stressing such a tonal harmony Monet showed an understanding of decorative unity which was to be subject before long to a colouristic metamorphosis, and that development is anticipated here in the bold turquoise horizon, whose note is echoed in the damp reflective surfaces of rocks and posts. Monet was already sensitive to much more than the merely local colours such as those which indentify the cliffs and meadow; he was fascinated by the interaction of light and colour, and to his interest in the painting of water, more than to anything else, is due the evolution of his impressionism.

Several of the painters who formed the Impressionist group had originally met over a decade before their first exhibition. Though Monet later in life prided himself on having been largely self-taught, Boudin and Jongkind apart he had also had some experience of a more formal training in Paris. He first met Pissarro in 1860, at the Atelier Suisse, where

9. *Pointe de la Hève, at Low Tide.* 1865.
Oil on canvas, 90.2 × 150.2 cm. (35½ × 59¼ in.) Fort Worth, Texas, Kimbell Art Museum

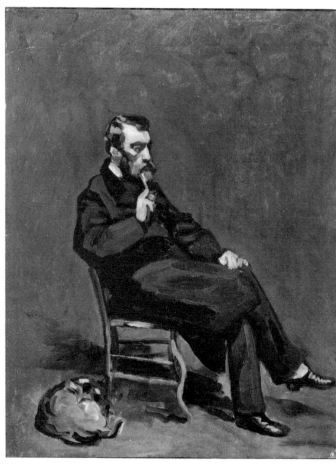

11 (above). *Man with a Pipe*. 1864. Oil on canvas, 45 × 34 cm. (17¾ × 13½ in.) Private collection

10 (left). *Portrait of J. F. Jacquemart*. 1865. Oil on canvas, 99 × 61 cm. (39 × 24 in.) Zürich, Kunsthaus

little instruction was given but where it was possible to work from the model. After an interval of military service spent partly in Algeria (1861–2) he attended the studio of Charles Gleyre, a successful classicizing academic painter, with whom Monet had been advised to work by the painter Toulmouche, a relative. Monet professed a dislike of Gleyre's academic regime, but he did meet Renoir, Sisley and Frédéric Bazille there. Bazille was

to play a particularly important part in Monet's life until his death in the war of 1870–1. The two worked together in Normandy in 1864 and shared a Paris studio later in the decade. The tall Bazille posed for at least three of the figures in the *Déjeuner sur L'Herbe* of 1865 (Plate 15). His financial support became indispensable to Monet, whose correspondence shows a somewhat ungracious petulance whenever his friend failed to respond

18

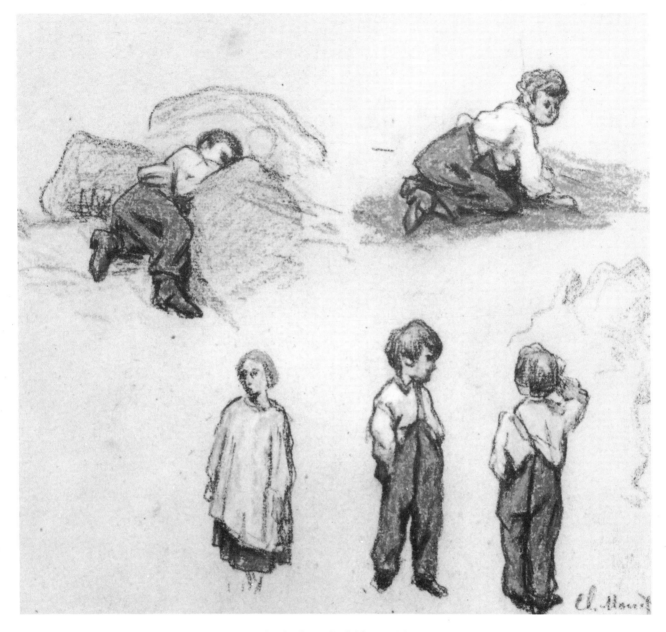

12. *Studies of Children.* 1864.
Pastel, 22.2 × 23.5 cm. (8¾ × 9¼ in.) London, Sotheby Parke Bernet & Co.

quickly to his requests. One of Bazille's friendly acts was to buy the *Women in the Garden* (Plate 7) for the sizeable sum of 2500 francs, payable in monthly instalments of 50 francs.

These two large paintings show that Monet shared with Manet the ambition to set near life-sized figures in the open air, and in Monet's case also to paint them there. The *Man with a Pipe*, who has been identified as Jongkind (Plate 11), occupies no space and is conventionally lit. *J. F. Jacquemart* (Plate 10) is scarcely more convincingly related to his elaborated environment: the picture is both narratively and pictorially inconsistent when considered in terms of the Realist and

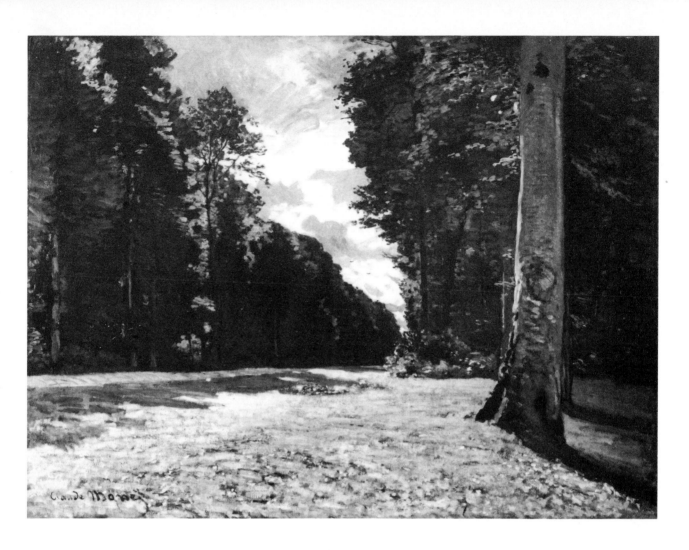

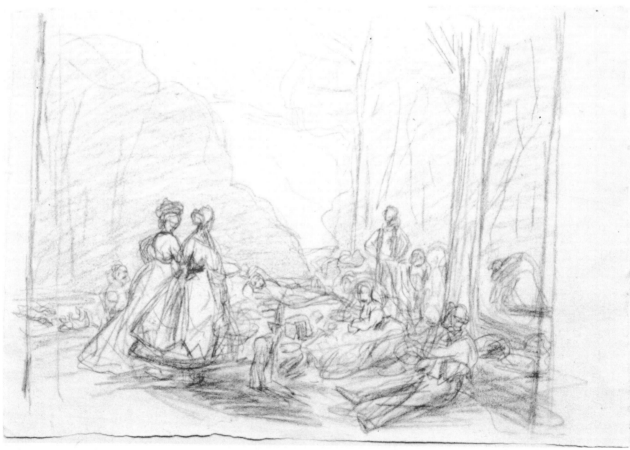

Naturalist preoccupations of the time. It may be said, however, that Courbet, whom Monet met at about this time and to whose memory he always remained devoted, was not always more successful.

Working with figures on a smaller scale was obviously easier, not least because the aesthetic requirement of unity was less vulnerable. The small boy who was studied several times in a pastel of 1863 (Plate 12) appears in one of these precise poses as a tiny figure in a farmyard scene painted that year. One is reminded of Monet's praise, in a letter written to Boudin in 1859, of the painter Troyon's Salon piece that year, inhabited by 'cattle in every position ... movement and disorder'. Much later Monet told his faithful dealer, Paul Durand-Ruel, that he did not consider draughtsman-ship to be his *métier*. 'It frightens me how clumsy I am,' he wrote in 1890. In fact it was not incapacity, but a conflict of sensibilities that he came to fear. Pissarro never became a colourist as did Monet, but his protestation that 'precise drawing destroys all sensations' could stand as a statement of Monet's mature view, anticipated in the little figures of wood-gatherers, who are inhabitants but not pro-tagonists in his landscape of 1864 (Plate 17).

Monet's painting of his mistress, Camille Doncieux—the *Woman in the Green Dress* (Plate 16), which appeared at the 1866 salon—was reputedly painted in four days as a substitute for an enormous canvas over six metres in width which he had been unable to complete in time. *Le Déjeuner sur l'Herbe* (Plate 15) is a sketch for this uncompleted

13 (opp. top). *The Road at Chailly*. 1865. Oil on canvas, 97 × 130 cm. (38⅛ × 51⅛ in.) Copenhagen, Ordrupsgaardsamlingen

14 (opposite bottom). Study for *Déjeuner sur l'Herbe*. About 1865. Black crayon on blue paper, 31.4 × 46.7 cm. (12⅜ × 18⅜ in.) Washington D.C., Collection Mr and Mrs Paul Mellon

15 (below). *Déjeuner sur l'Herbe*. 1865. Oil on canvas, 130 × 181 cm. (51¼ × 70 in.) Moscow, Pushkin Museum

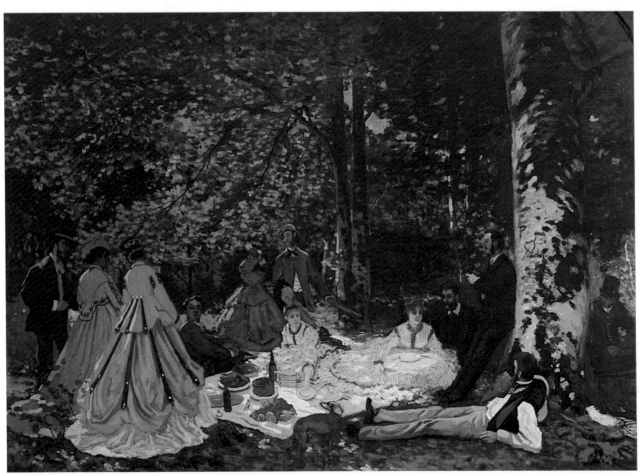

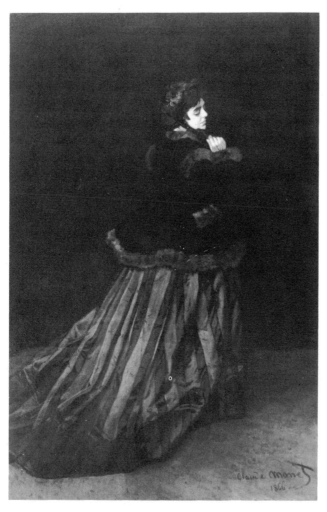

16. *Woman in the Green Dress* (*Camille*). 1866. Oil on canvas, 228 × 149 cm. (89¾ × 58⅝ in.) Bremen, Kunsthalle

canvas. Whether or not the sketch was executed *in situ*, the huge canvas itself obviously could not have been. Courbet was much impressed by this new recruit to the Realist cause when he saw Monet at work on it in the studio he shared with Bazille at the end of 1865. The landscape was of course first studied from nature, and a comparison between a painting made that summer in the forest of Fontainebleau (Plate 13) and a preliminary drawing for the uncompleted large canvas as a whole (Plate 14) shows the combination of direct observation and stage-management in his method. The realist attitude is apparent in the absolute contemporaneity of the fashions, while Monet's still pre-Impressionist naturalism is evident in his interest in the quality of light. In the previous year's painting with wood-gatherers his approach had been comparatively simple: to contrast a large, strongly lit area with an expanse of shadow. Now, by turning his view into the wood instead of down the road, he was able to produce a much greater pictorial animation, as the sunlight falls on patches of reflective and translucent foliage.

Women in the Garden (Plate 7) was a logical successor to the *Déjeuner sur L'Herbe*, not only because two, perhaps three, of the costumes worn by the ladies in the earlier painting reappear, but also because this canvas, though very large, could still have been executed out of doors. The painting was not in fact completed in the open air, but Monet's conviction of the validity of this principle was demonstrated by his digging a trench in the garden into which he could lower the canvas in order to work on its upper parts. No single story better illustrates that courage of his convictions which made the young Monet the natural 'leader' of the Impressionists. But for all its vigour this painting cannot be considered an unqualified success. This is particularly true, paradoxically, of the quality of

17. *Road in the Forest with Wood-Gatherers*. 1864.
Oil on panel, 58.7 × 90.2 cm. (23⅛ × 35½ in.) Boston, Museum of Fine Arts, Henry H. and Zoe Oliver Sherman Fund

light: the jagged shadow that lies over the foreground is not inconsistent, but tends to appear as much the product of an arbitrary decision as a naturalist record, and large parts of the painted surface remain dead, above all when considered by the standard of Monet's later achievements.

Monet painted a number of large figure compositions in the earlier part of his career. In the same year that he produced the much-admired *Woman in the Green Dress*, he painted, or at least began work on, a *Woman in White*. Was he recalling Whistler's *Symphony in White*, which had been seen at the *Salon des Refusés* in 1863 along with Manet's *Déjeuner sur l'Herbe*? The project was abandoned, and he used the same canvas to paint a large view of the harbour at Honfleur which, along with *Women in the Garden*, was rejected by the 1867 Salon jury. A demand was made at this time by numerous artists for a new *Salon des Refusés*, where the public might form its own opinion as to the jury's conduct. But this was refused, and the ideas that led to the formation of the *Société Anonyme* began to take shape.

In 1868 Monet painted his large portrait of

23

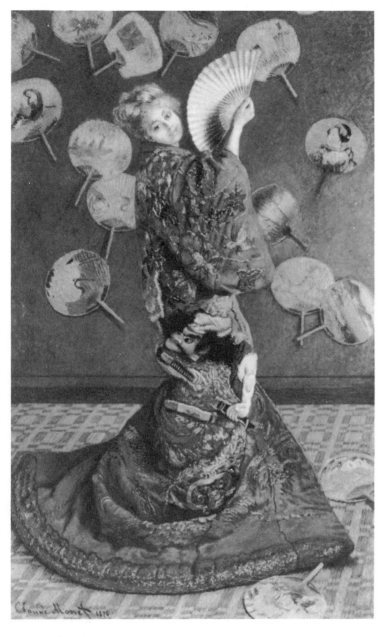

18. *La Japonaise*. 1876. Oil on canvas, 231.5 × 142 cm. (91 × 56 in.) Boston, Massachusetts, Museum of Fine Arts

Madame Gaudibert (Plate 19), wife of a patron at Le Havre of whom he made a companion canvas. The stuffs are less richly textured than those worn by Camille in the painting of 1866, but there is much in common with the *Women in the Garden*. A multicoloured shawl, worn with a nonchalance again suggesting a Whistlerian taste, is here the equivalent of the sprays of flowers gathered by the ladies in the earlier painting. The greys still make the painting, and these true local colours enliven both canvases but are not subject to modification by the light.

Toward the end of 1868 Monet painted *The Luncheon* (Plate 2), with its clear implication of the artist's expected arrival to take his place opposite his mistress and their son. The group, including a visitor and a maid, is disposed with a naturalness which exceeds that in Manet's two famous paintings shown at the Salon in 1869. How close the painters were can be deduced from the presence of sketches after Monet's painting and Manet's *Breakfast in the Studio* and *The Balcony* on successive sheets of one of Bazille's notebooks. There are indications that Monet may have made slight alterations in his composition under Manet's influence, but the comparison brings out above all the more hard-headed realism of Monet in this last of his large multi-figure compositions.

Something 'Japanese' about Monet's works was already noticed by a critic in 1873. His way of treating water was then under discussion, and it was thought to show traces of the techniques used by Japanese printmakers. Monet had acquired some Japanese prints in Holland in 1871, if not before, and these formed the nucleus of the extensive collection with which he later decorated the dining-room of his house at Giverny. *La Japonaise* (Plate 18), which he successfully exhibited at the second Impressionist Exhibition in 1876, owes more, however, to contemporary fashion than to anything truly Japanese. Camille's graceful,

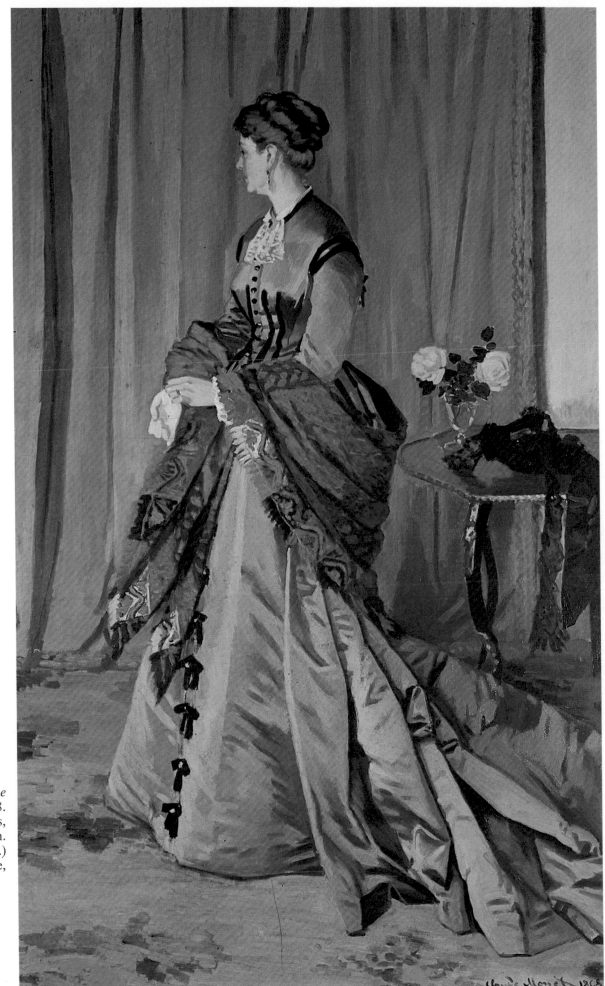

19. *Madame
Gaudibert*. 1868.
Oil on canvas,
216 × 138 cm.
(85 × 54½ in.)
Paris, Louvre,
Jeu de Paume

if mannered, pose under her blonde wig is a pure charade, as are the accoutrements in this curious extension of Monet's interest in the fashions of the 1860s. With its interest in pattern and ornament, and its simple spatial organization, whereby the canvas at first reads as a mass of scarlet on blue, it is what Whistler might have called a 'harmony in crimson and cornflower'. But this planned, in Whistlerian terms 'arranged' painting, deliberately decorative no less in palette than in design, anticipates qualities Monet was later increasingly able to find in nature itself. To make such a painting was to train the eye, to encourage the develop-

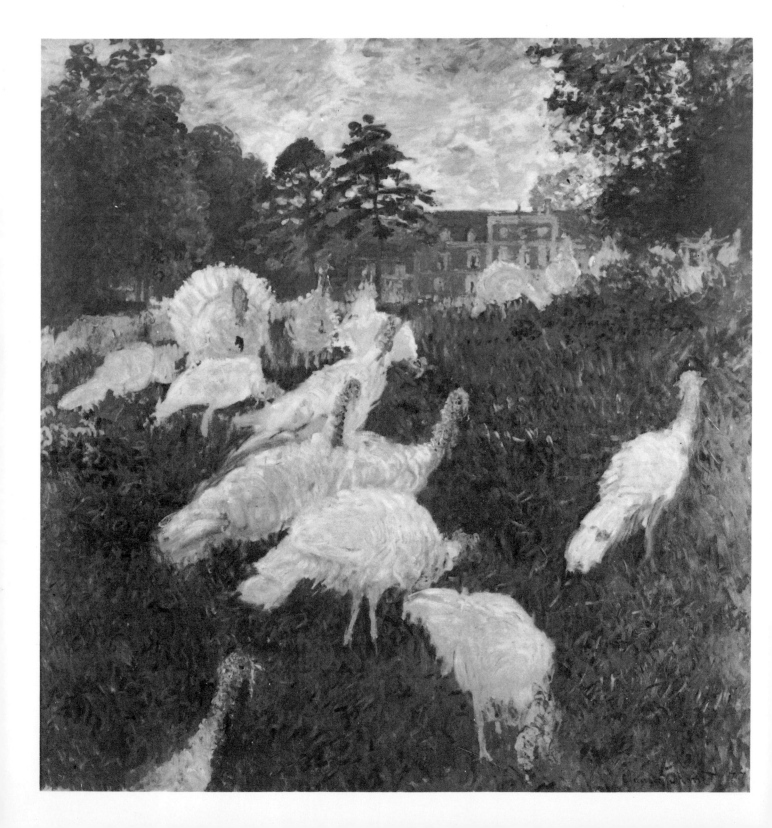

ment of an increasingly editorially-directed vision, which need not invent, but certainly selected.

In the 1876 exhibition there was also a much smaller, and recognizably 'Impressionist' painting, where Camille and young Jean appear set against a blue sky flecked with boldly brushed white clouds (Plate 21). Here too there is elegance, and here too a remarkably selective palette: the clothing of the figures is largely composed of the range of blues found in the sky, and the underside of Camille's parasol is painted in the same deep green shaded with charcoal-coloured marks that occurs in the shadow she casts on the grass. (Monet was not yet always using the exclusively spectral palette that he employed from the eighties on.) This degree of 'arrangement' did not, however, preclude the scientific naturalist gesture of including a few complementary reddish marks in the sunlit areas. Such a painting shows that a quite radical Impressionism was not necessarily incompatible with an aspiration to the decorative.

This was confirmed by two of Monet's exhibits at the third group exhibition in 1877 (Plates 20, 22; the second of these is a larger version of the canvas seen at the exhibition). They formed part of a group of four decorative panels—the term 'panel' was used by Monet to denote their decorative function—painted for his patron Ernest Hoschedé, whose wife Alice eventually became Monet's second wife. The artist always had a particular regard for his *White Turkeys*. In 1903 he spoke of it as worth any two of his other canvases, and this despite the fact that the painting remained unfinished, as indeed it was described in the catalogue when first exhibited. The specifically

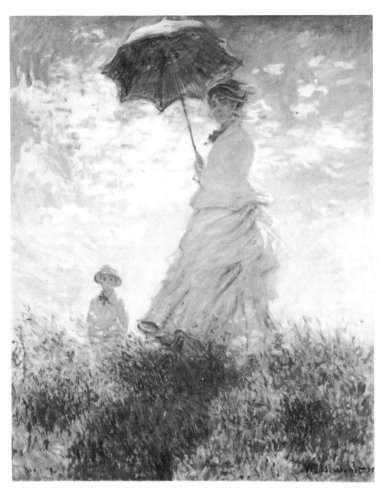

20. *White Turkeys*. 1876. Oil on canvas, 174 × 172 cm. (68½ × 67¾ in.) Paris, Louvre, Jeu de Paume

21. *The Promenade: Woman with a Parasol*. 1875. Oil on canvas, 100 × 81 cm. (39⅜ × 31⅞ in.) Washington, National Gallery of Art, lent by Mr and Mrs Paul Mellon

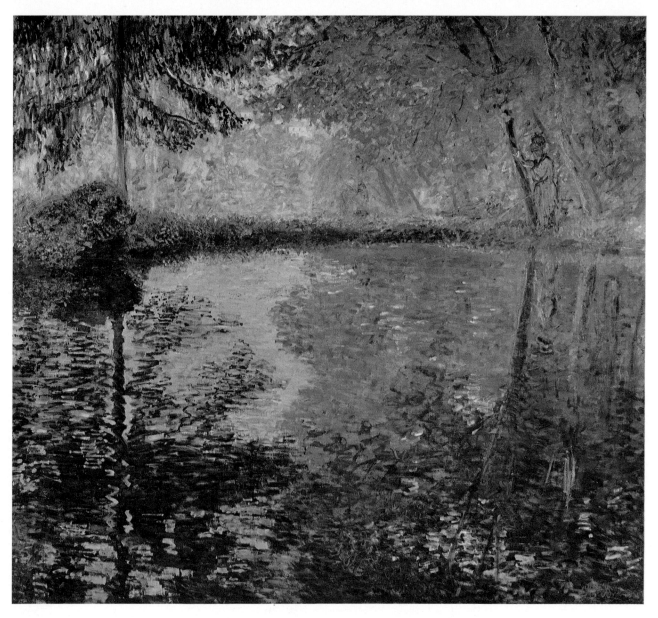

22 and 23 (detail). *Corner of the Pond at Montgeron.* 1876.
Oil on canvas, 172 × 193 cm. (67¾ × 76 in.) Leningrad, Hermitage

decorative quality of the two works resides partly in their unusually large size, and the almost perfectly square format of the *Turkeys* certainly contributes to our sense of the painting as patterned surface. The unusual composition—and here the word is not at all ambiguous—allowed Monet to exploit the decorative aspect of the birds themselves, and perhaps also to make a structural link between these two canvases. In each case there is a horizontal caesura at the same point—the canvases are exactly the same height. As befits commissioned decorations, all four were views of the Hoschedés' country property, but particularly in *The Pond at Montgeron* Monet's uncompromised Impressionism did not permit him to flatter. There is a haze which almost conceals the figures on the further bank, an atmosphere which turns the distant view into something sensed rather than seen, but the painting as a whole has not sacrificed compositional stability and colouristic structure.

28

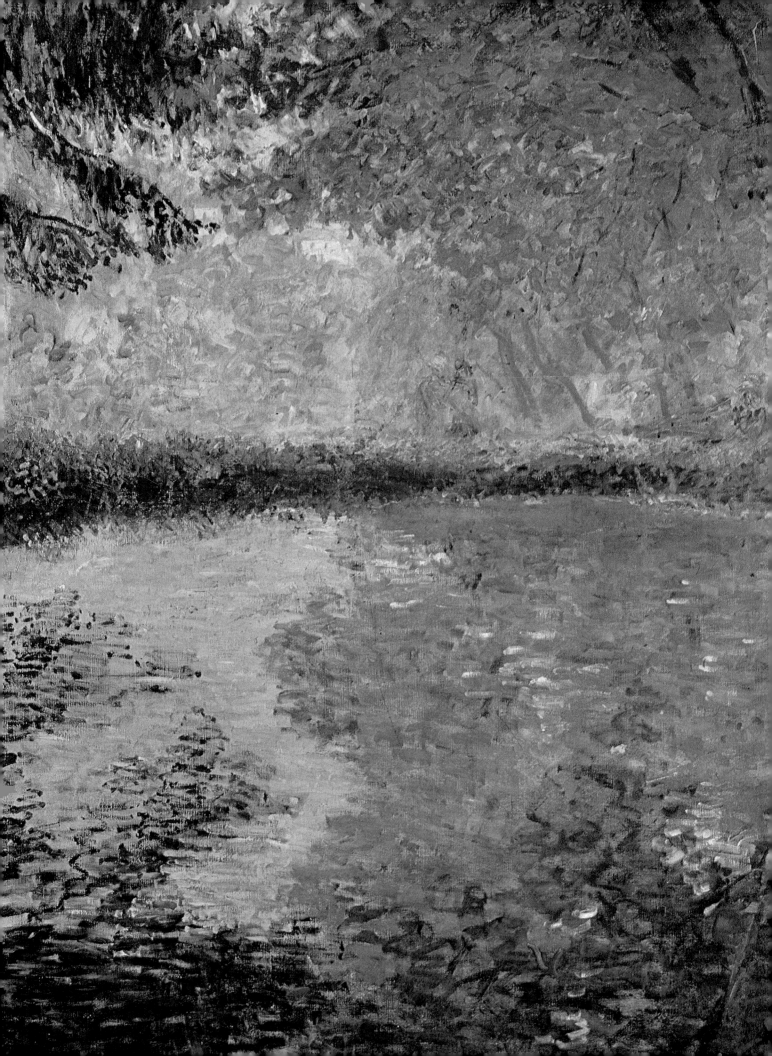

Monet's reputation was identified in his lifetime with his skill as a painter of water to a degree that bordered on cliché, not least among his artistic colleagues. Manet's praise in such terms has already been quoted; for Puvis de Chavannes, the most professional painter of public decorative works of the time, he was 'that inspired painter of water'. The phrase is from a letter Puvis wrote in 1885 to Berthe Morisot, for whom Monet had the previous year painted one of his specifically decorative canvases. Monet acquiesced in this perhaps unduly limiting identity and even encouraged it. He once grumbled to Renoir, in the Louvre, that Canaletto had omitted the reflections of his boats. Monet's exhibition in

24. *Riverside at Bennecourt*. 1868. Oil on canvas, 81 × 100.3 cm. (31⅞ × 39½ in.) Chicago, Art Institute

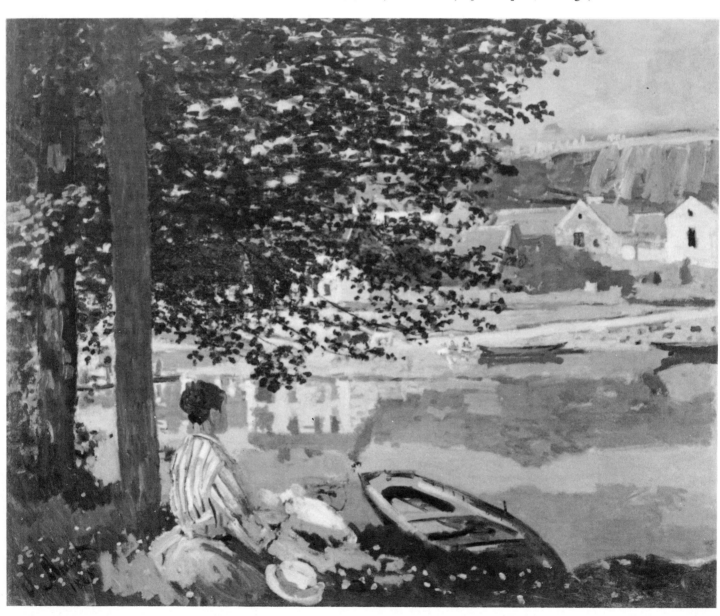

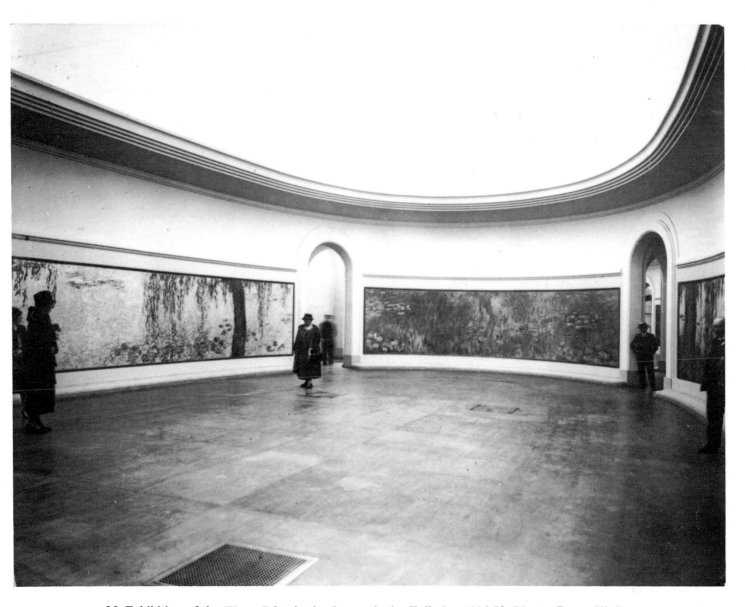

25. Exhibition of the *Water-Lilies* in the Orangerie des Tuileries. 1916-23. Photo: Roger-Viollet

1909 of forty-eight paintings of water-lilies, under the general title of 'Water-landscapes', and the decoration of two rooms at the Orangerie in Paris were the apotheosis of this lifelong passion (Plate 25). Whatever the painter's conscious intention may have been, his progress as a painter of water in particular is easily felt to have been from a classic, or analytical art, to one that is romantic or emotional.

Monet's conscious concern with the development of his art, and that this development should be recognized, is indicated by his habit of including earlier paintings among the more recent canvases in his exhibitions. Thus *The Beach at Sainte-Adresse* (Plate 26), a painting of 1867, was borrowed from its owner so it could be shown in the Impressionist Exhibition of 1876 among works of a very different kind. In 1889 it appeared again, together with the *Riverside at Bennecourt* of 1868 (Plate 24), in a two-man exhibition he shared with Rodin at a commercial gallery. Both paintings can still be seen together at the Art Institute of Chicago.

31

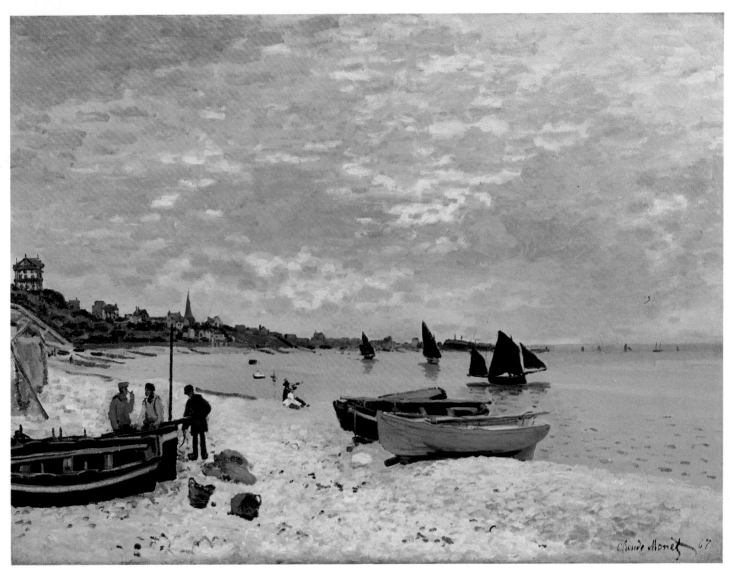

26. *The Beach at Sainte-Adresse.* 1867. Oil on canvas, 72.4 × 104.8 cm. (28½ × 41¼ in.) Chicago, Art Institute

It is surprising, on looking at reproductions of the two works, to discover that they are almost identical in size. The one is *conceived* with a breadth which suggests a larger canvas, the other *painted* with a breadth which suggests a smaller one, more in the nature of a sketch. In the earlier painting there is still some sense of artifice: the scale of the figures in particular seems suspect, not necessarily in relation to their boats but because the 'framing' of the scene implies a closer stance than does their size. In the other, more intimate canvas— intimate not least because this figure is again surely Camille—the broader handling is no doubt the result of a speed of execution which was to remain a talent capable of arousing his colleagues' envy. It was developed not because there was any necessary intention to make a 'sketch', but because direct confrontation with the motif, without artifice, demanded it. This rapidity may well itself have contributed to his ever-growing perception of changes in the atmosphere, not just with the seasons as had sufficed earlier painters, but with the time of day. A painter working fast must be able to choose a palette and select quickly from it: so

27. *The Jetty at Le Havre*. 1868. Oil on canvas, 147 × 226 cm. (57⅞ × 89 in.) Tokyo, private collection

it was that in his later colourism the hour was not so much illustrated as evoked.

The change Monet's art was undergoing in the late 1860s is demonstrated by the paintings he made of La Grenouillère, a bathing and boating palace at Bougival near Paris, where he worked with Renoir in 1869. The works painted there have long been recognized as the clearest indication yet that a new kind of painting was emerging. The conventional flecks that mark the surface of a calm sea lapping the beach at Sainte-Adresse, or the glassy surface of the Seine at Bennecourt no longer sufficed. Nor did the energetic, but still essentially illustrative, painting of water in a sea painting like *The Jetty at Le Havre* (Plate 27), a work which though rejected by the Salon jury in 1868 had been praised by Zola for its true rendition of dirty, sandy water, so different from the usual 'marine paintings in sugar-candy'. That painting is an instance of what may be called positivist naturalism, but there appeared at La Grenouillère something different, an Impressionist naturalism which was no less closely based on observation, but which treated the intrinsically unpaintable

33

element of water less as a thing in itself than as a vehicle of sensation.

Monet's painterly response to the quality of sight rather than to the thing seen, which itself owed much to Jongkind's method, was to prove too much for positivists like Zola, who grew more and more convinced that such painting remained disappointingly sketchy and did not properly come to terms with the 'Real'. This implied fallacy was to be inverted by enthusiasts imbued with Symbolist ideas, who could later speak of the essential element of subjectivity, of concerning oneself with the sensation rather than with an intellectually disciplined record of reality. The Impressionist-influenced German painter, Max Liebermann, spoke of Impressionism as a *Weltanschauung*—not just a view of the world but a world-view, a philosophy rather than a movement in painting. All this is a long way from the intentions of the hard-headed Monet, but the subjective element in an art of sensation, an element which grew more marked as he grew older, was first clearly implied, quite without poetic or philosophic overtones, by the moving waters at La Grenouillère.

The painting of La Grenouillère here illustrated (Plate 28) was once owned by Manet. In 1884, the year after Manet's death, Monet wrote to his dealer Durand-Ruel of his own wish to acquire something by the master, 'a sketch, something artistic'. The words suggest that Monet continued to make a distinction between a sketch and a finished work, to the advantage of the former, but his work at La Grenouillère had in practice consolidated the two. Like his difficult friend Cézanne, he preferred to be 'right in practice if not in theory': Monet subscribed to no theory but to a principle, that of the need to be true to the actuality of one's own vision. This artist, who said towards the end of his life: 'I paint as the bird sings,' had told Bazille in 1868: 'one gets too preoccupied by what

34

28. *La Grenouillère*. 1869.
Oil on canvas, 75 × 100 cm. (29½ × 39⅜ in.) New York, Metropolitan Museum of Art, H. O. Havemeyer Collection

29. *Meditation.* 1871. Oil on canvas, 48 × 75 cm. (19 × 29½ in.) Paris, Louvre, Jeu de Paume

36

one sees and hears in Paris ... if what I'm doing here has any value it is that it doesn't look like anyone else ... the further I go the more I realize that people never dare to express frankly what they experience.'

Monet's next opportunities to exploit his interest in the pictorial possibilities of surfaces of water more intimate than those of the sea arose in London and in Holland. He travelled to London late in 1870, chiefly in order to escape from the Franco-Prussian War, which had been declared on 19 July. Of the six known paintings made on this visit—he must surely have made more, for he remained there until the end of May—one is the charming *Meditation* (Plate 29). This further image of Camille was thought by the painter's friend and biographer, Gustave Geffroy, to reveal in Monet an expressive figure-painter, who could have been the greatest portraitist of the time. It is in fact, however, an exercise in contemporary genre, with not a little in common with Manet's paintings of such themes. It also has a certain spirituality, far less rhetorical than Rossetti's but owing something perhaps to the climate of English art, and aimed at the English market, though it was bought by Paul Durand-Ruel whom he first met in London.

The Pool of London (Plate 30) is considerably smaller than *La Grenouillère* and is treated in a different way, which to some extent anticipates the artist's method in the series of Thames views that he made at the beginning of this century (see Plate 61). In that late series he was more than ever concerned to derive from London's fogs, and its occluded skies, a unified colouristic harmony. This was foreshadowed in 1871 by the breadth of handling in the areas of variation where the river reflects the sky, something very different from the close-up variegation noticed at La Grenouillère, and in Holland later that year. It is not surprising to find that three of Monet's London paintings that survive from this visit

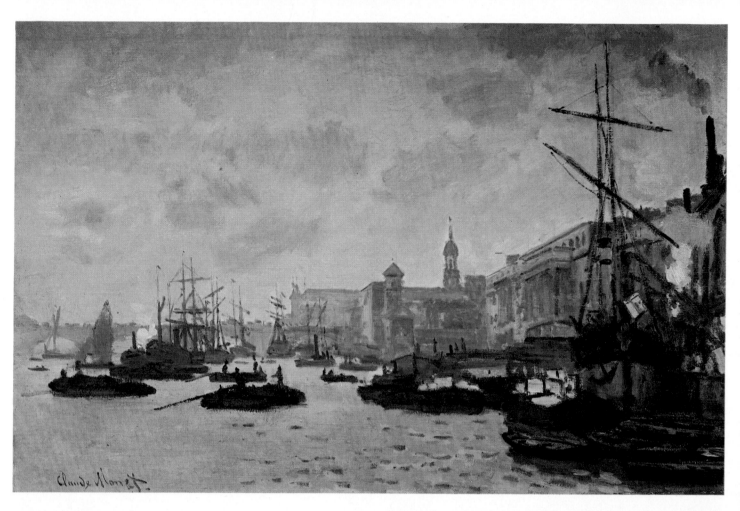

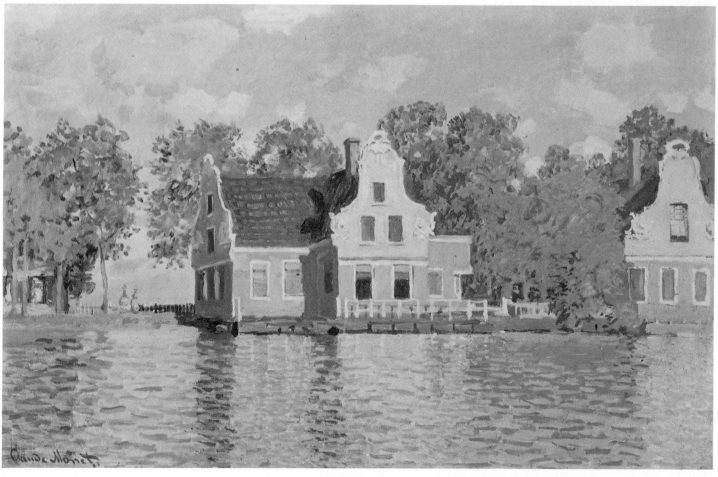

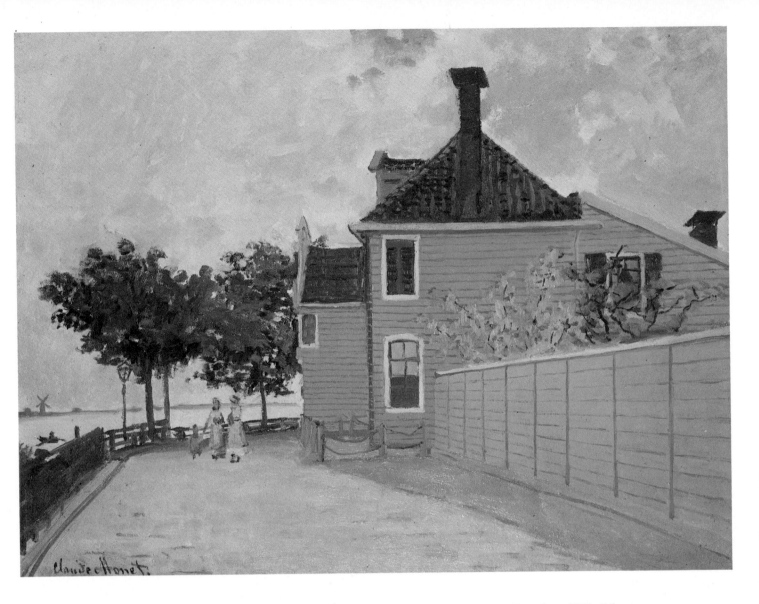

30 (opposite top). *The Pool of London.* 1871. Oil on canvas, 49 × 71 cm. (19¼ × 28 in.) Private collection

31 (opposite bottom). *Houses by the River Zaan.* 1871. Oil on canvas, 47.5 × 73.5 cm. (18¾ × 29 in.) Frankfurt, Städelsches Kunstinstitut

32 (above). *Blue House at Zaandam.* 1871. Oil on canvas, 45.1 × 60.6 cm. (17¾ × 23⅞ in.) Private collection

should be views of the Thames, a subject in which Pissarro, who was in London at the same time, took no interest.

Houses by the River Zaan (Plate 31) seems powerfully expressive, not only of its motif, but of the artist's happy response to a town whose people and picturesque sites gave him much pleasure. He painted many windmills, but the brightly decorated houses pleased him

as much, for their colours as well as for their reflections in the water. He was particularly satisfied with his *Blue House at Zaandam* (Plate 32). Here a thin cloud-cover allowed the building's local colour to speak more clearly than a strong sunlight would have done. Here for once was an opportunity to revel in a clear and simple hue without the enormous task of first analysing the colours in the scene and then

correlating them in an effective unifying synthesis. 'There is enough here in Zaandam to paint for a lifetime,' he wrote to Pissarro, and there is a sense of relaxation in these works, in which something picturesque was found and enjoyed for its own sake, whereas in London his more conscious innovative professionalism had predominated. The London painting was the truer prototype of the *Impression, Sunrise* (Plate 39) and the views of the *Boulevard des Capucines* (Plates 34, 35, 36), at the exhibition of 1874. These, like the much later *Houses of Parliament* of 1905 (Plate 33), were works whose true theme of light and atmosphere was much more demanding of the artist's powers of concentration than the relatively simple task of recording an interesting motif. The romantic, even Turneresque, overtones of this later work were not factitiously superadded, but distilled from an analytical, rather than merely descriptive, habit of vision.

One of Monet's paintings of Zaandam was bought by Charles Daubigny, who painted in the manner of the artists of the Barbizon School. Daubigny was much admired by the Impressionists, and as a jury member had worked for the admission of Monet's paintings to the Salons of the 1860s. In 1871 he too was in London, working on views of the Thames, and it was he who introduced Monet to Durand-Ruel. The painting he bought was apparently made from a boat in the middle of the river, and so recalls the famous studio-boat Daubigny himself used, an example followed by the younger man, who purchased such a craft when he returned to France (Plate 37). Monet lived by the river Seine for the rest of his life, first at Argenteuil, a few minutes by

33. *London, Houses of Parliament.* 1905. Oil on canvas, 81 × 92 cm. (31⅞ × 36¼ in.) Paris, Musée Marmottan

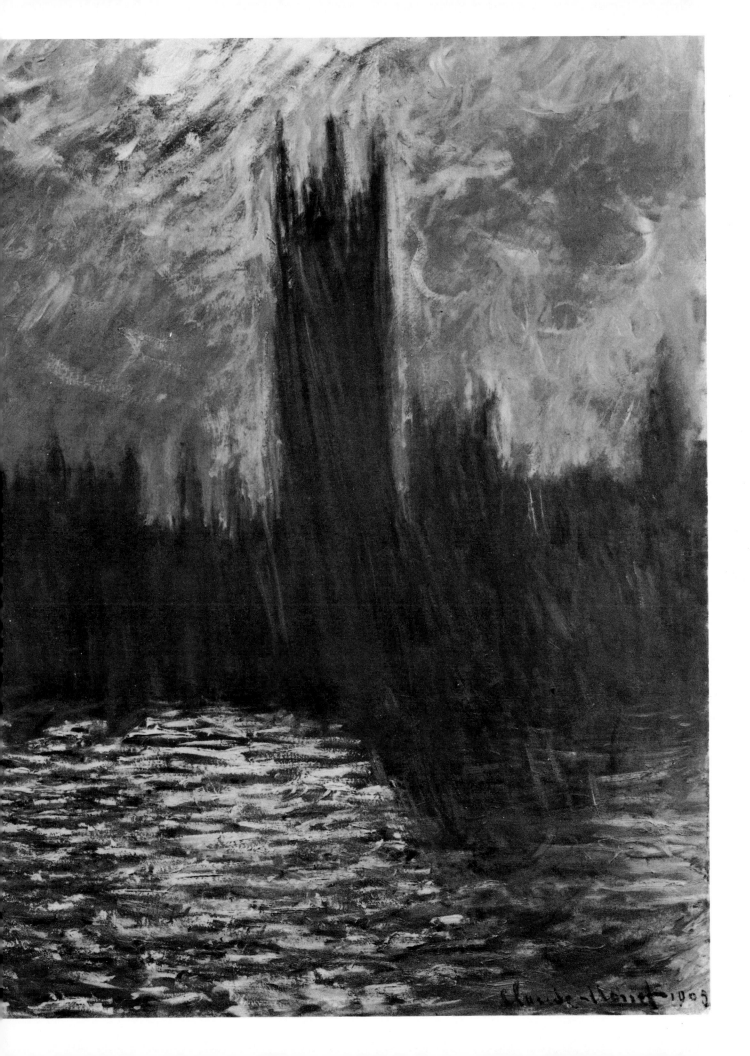

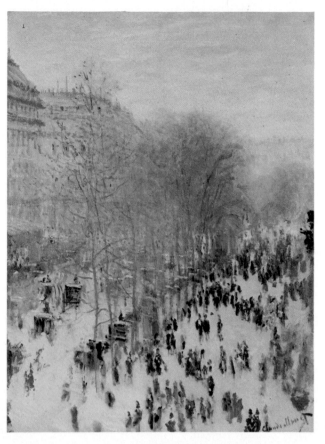

train from the Gare Saint-Lazare (from late in 1871 until 1878), then at Vétheuil, half-way downstream to Rouen. He returned to Poissy, nearer Paris, in 1881, but by 1883 had settled at Giverny, not far from Vétheuil, which remained his home until his death in 1926. At Giverny he constructed a water garden, the deliberately created, rather than discovered, subject of many of his last paintings. Camille Monet died in 1879, and the artist then lived for many years with Alice Hoschedé, eventually marrying her in 1892 after her husband's death. She died in 1911.

34 (left). *Boulevard des Capucines*. 1873–4. Oil on canvas, 79.4 × 59.1 cm. (31¼ × 23¼ in.) Kansas City, Atkins Museum, Nelson Gallery, Gift of Kenneth A. and Helen F. Spencer

35 (below) and 36 (opposite, detail). *Boulevard des Capucines*. 1873. Oil on canvas, 61 × 80.3 cm. (24 × 31⅝ in.) Moscow, Pushkin Museum

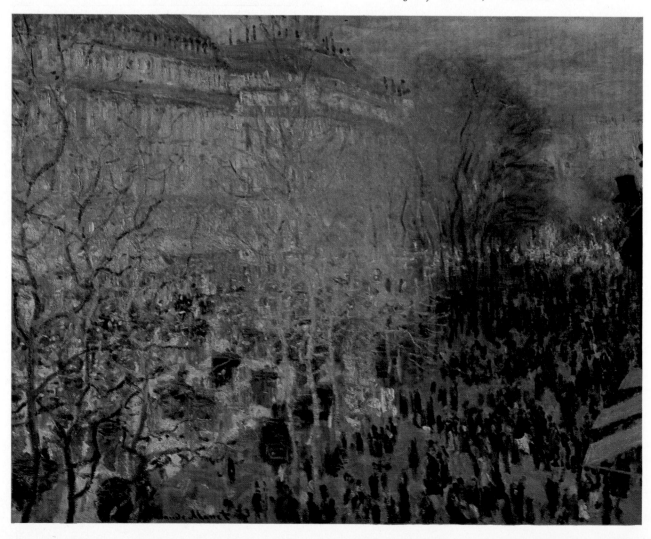

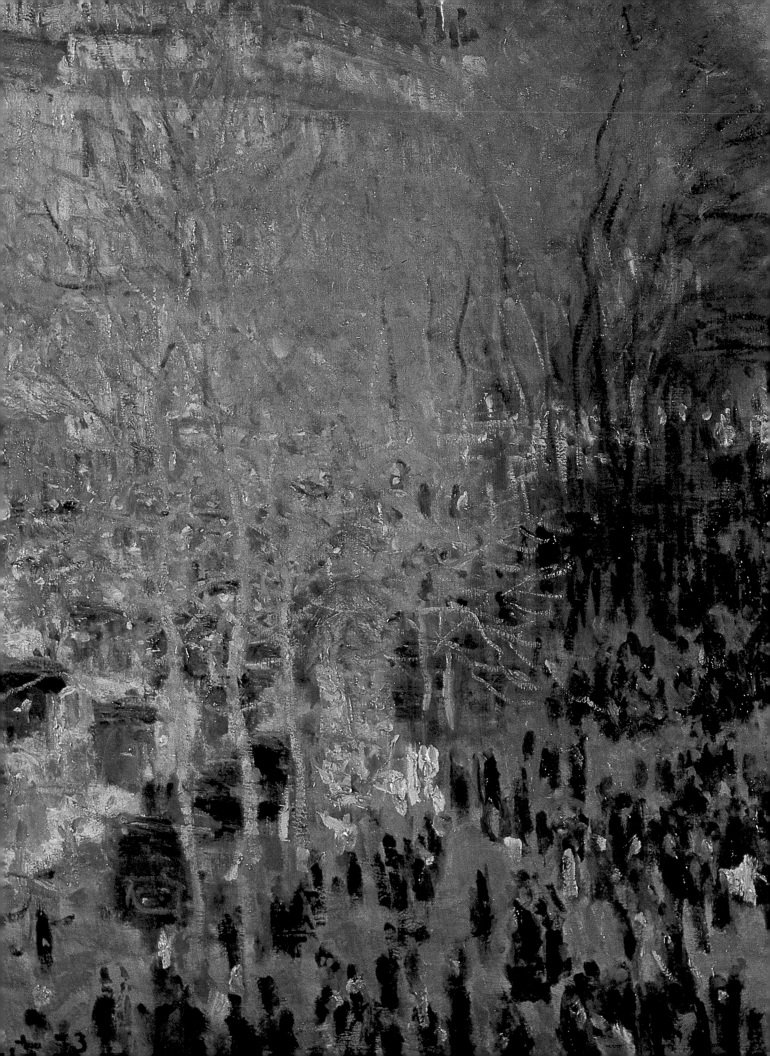

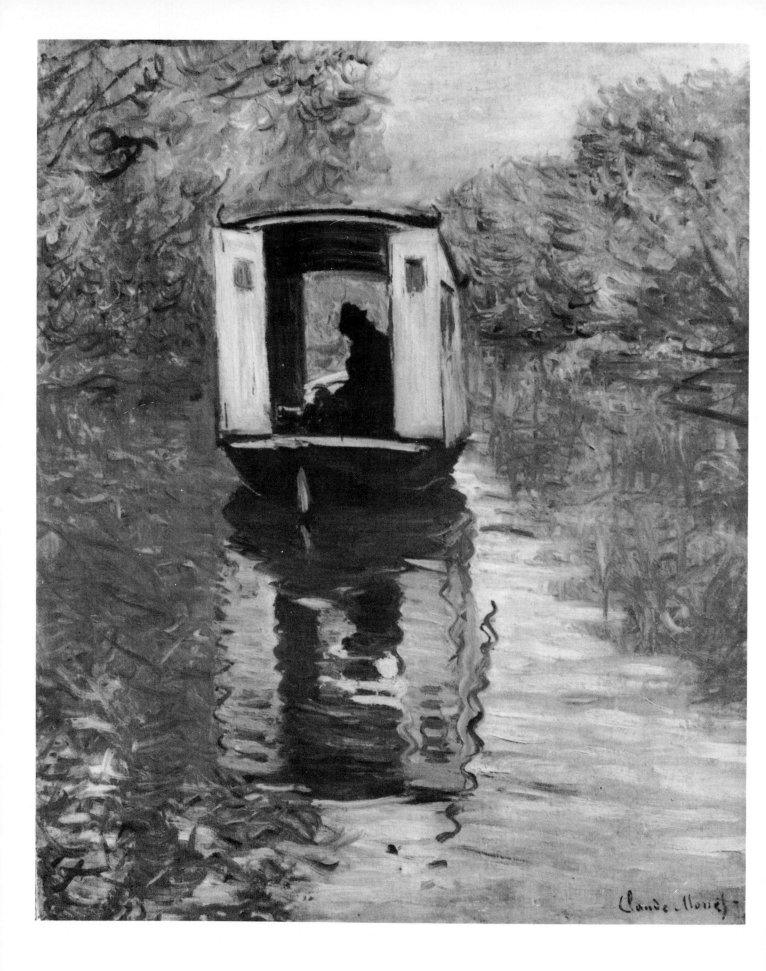

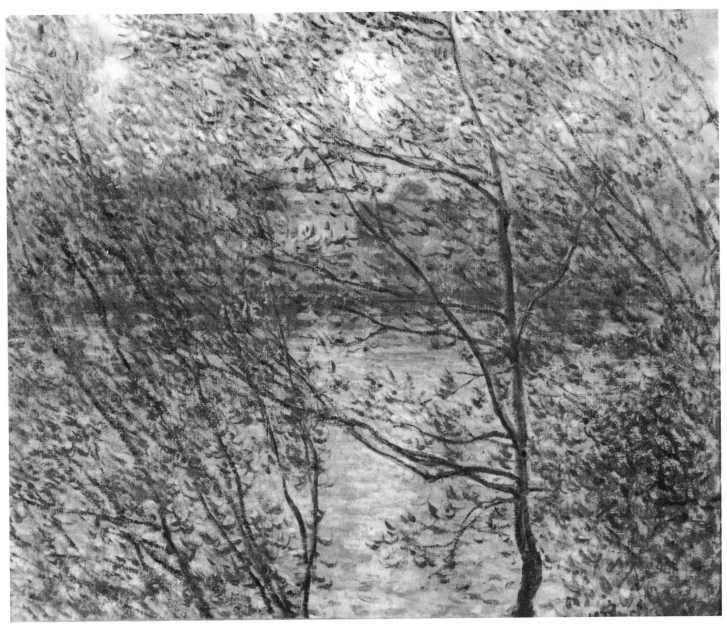

38. *Spring, the River seen through the Branches.* 1878.
Oil on canvas, 59 × 79 cm. (23¼ × 31⅛ in.) Paris, Musée Marmottan

Spring, the River seen through the Branches (Plate 38), a painting with a particularly challenging motif, was painted from the Ile de la Grande Jatte, itself the subject of a famous painting made by Georges Seurat a few years later. Whereas Seurat was to be

37. *Studio Boat.* 1876. Oil on canvas, 72 × 60 cm. (28⅜ × 23⅝ in.) Merion, Pennsylvania, Barnes Foundation

interested in the human aspect, the variety of Sunday strollers and loungers, Monet as usual preferred subjective sensation to social observation. The Impressionists were sometimes known, metaphorically but misleadingly, as the *Intransigeants,* even the *Communards* of the art world, with the implication that they were revolutionaries. However, Monet's only known political stand of any note concerns his support for Dreyfus in the notorious *affaire* of

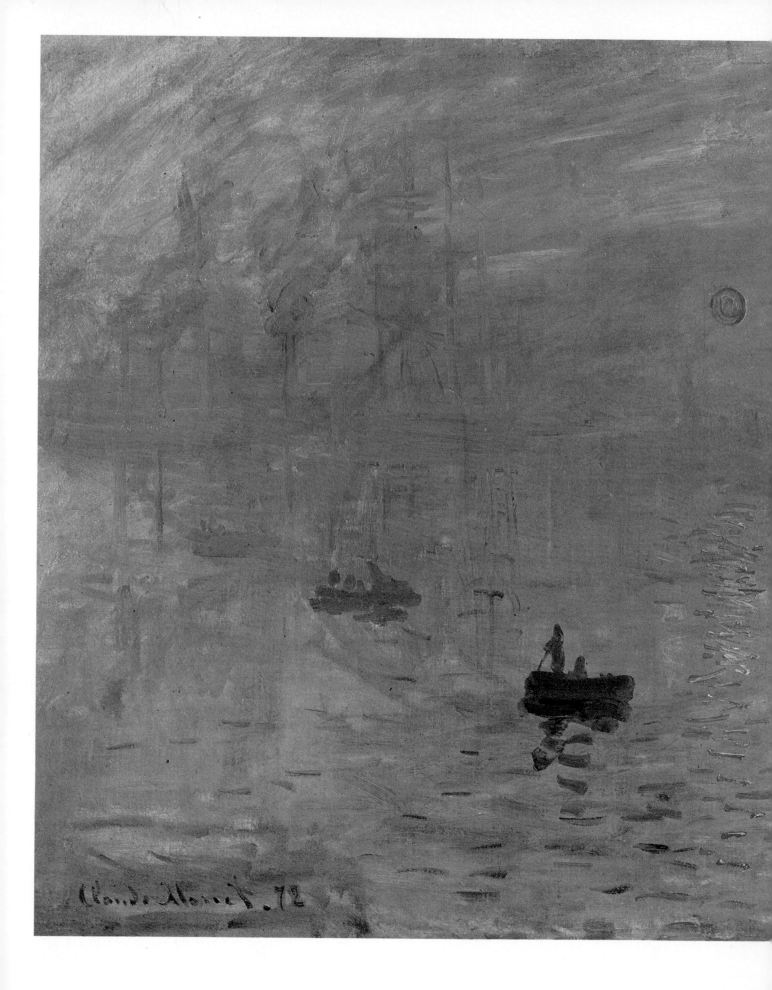

the 1890s, when he admired Zola's public protest. He did become a friend of Georges Clemenceau, but there seems to have been no political significance in his association with the great Radical. In his relative detachment, Monet differed from the attitude prevailing among the Neo-Impressionists, who tended to associate progressive social attitudes with a scientific approach to art.

In such a climate of opinion it is not surprising that Pissarro, the most radically minded of the Impressionists, should have been tempted to adopt the Neo-Impressionist method of the 1880s, but insofar as Monet's art was 'scientific' it was so without pedantry. The critic Duranty might have been speaking of Monet in particular when he wrote in 1876, of the Impressionists as a group, that 'passing from intuition to intuition', they had managed to disengage the 'seven prismatic rays' from solar light and reintegrate them into a general harmony. There can be no doubt that Monet sometimes deliberately exploited the principle of complementarity, but only insofar as this was compatible with a frame of mind best expressed in a letter he wrote from Venice in 1908: 'I neglect the rules of painting (if such exist) in order to do what I feel.' The hostile critic who, in 1879, wrote of the Impressionists that they 'elevated their ignorance to the height of a principle' was, had he but known it, praising Monet.

Monet's long-standing trust only in himself and in his own individuality, that 'temperament' which Zola had identified as the mark of authenticity in art, led him to grow more and more distrustful of working in company with others. Having made a first brief visit to the Côte d'Azur with Renoir in 1883, he wrote to

39. *Impression, Sunrise*. 1873. Oil on canvas, 50.2 × 65.1 cm. (19¾ × 25⅝ in.) Paris, Musée Marmottan

Durand-Ruel of his intention to return there alone: 'I have always worked best on my own, and from my own personal impressions.' These impressions were lyrical in essence and could survive neither the risk of amalgamation with the sensibility of another nor too forced an analysis. What this meant in technical terms can be partially deduced from the comparison of two lists of colours, one in a letter of 1869 to Bazille, the other in a letter of 1905 to Durand-Ruel. The empirical naturalist of the 1860s asked his friend to send fresh supplies of nine colours, indicating that he had enough for the time being of all the others. In 1905 he spoke of six colours alone as sufficient for his palette, and none of them was an earth colour, let alone a black, such as appear in the earlier list. If there was to be a 'general harmony', it was now less the palette itself than the manner of its use that counted. The notion of 'science' was reduced—or elevated—to that of skill and above all of experience.

A connection has been made between politics, science, and Monet's continuing belief in 'progress'. In 1876 Mallarmé wrote of the essentially 'democratic' nature of Impressionism, an art which was free of the old cultural props and whose stress on the powers of sight, a property of all humanity, was comparable with the new Republican constitution after 1870. But by 'progress' Monet meant something wholly personal in relation to his own art and its development. His failure to achieve such progress, by which he seems to have understood above all progress toward the perfect reconciliation of the values of Truth and of Art as a quasi-autonomous decorative entity, led to frequent bouts of discouragement from the 1880s on. These bouts became so extreme that he scraped the paint off many canvases or actually destroyed them. As far as progress in the world at large was concerned, the extent to which it could conflict with Monet's own progressivism is indicated by his distaste for any changes, such as the felling of trees or the erection of telegraph poles, that might destroy his motif or alter it, or simply ruin a landscape.

Despite the superficially 'photographic' quality of some of his works, Monet never took up photography like Degas, perhaps not least because colour photography was still in its infancy. If some early colour photographs possessed a unifying 'cast' oddly comparable in one sense with the Impressionist interest in a unifying 'effect', the results were also obviously false, and thus likely to confirm Monet, if he saw them, in his belief that the painter's art was the surer guide to the truth. He did once ask John Singer Sargent to provide him with a photograph of the Houses of Parliament at a time when he was completing his series of *Londons* back at Giverny, though he went out of his way to assure Durand-Ruel that he had not in fact used this aid.

Given his general anti-technological and apolitical attitude it is not surprising that Monet was unwilling to stand for the mayorship of Giverny, despite assurances that he had an excellent chance of success. He also avoided contact with the Academy and refused the Legion of Honour.

In 1880 Monet, following an example set by Renoir the previous year, but to the annoyance of most of his colleagues, submitted two paintings to the Salon for the first time since 1870. It was a last, isolated attempt to attain success through the conventional channels. The view of Lavacourt (Plate 40), which was accepted, was submitted together with an almost identically sized scene of the river under ice-floes, which was not. Intended for the Salon, both were larger than the average size of his canvases, and the rejected painting appeared, together with a smaller view of the icy river painted near Vétheuil in the previous hard winter (Plate 41), at a one-man exhibition

48

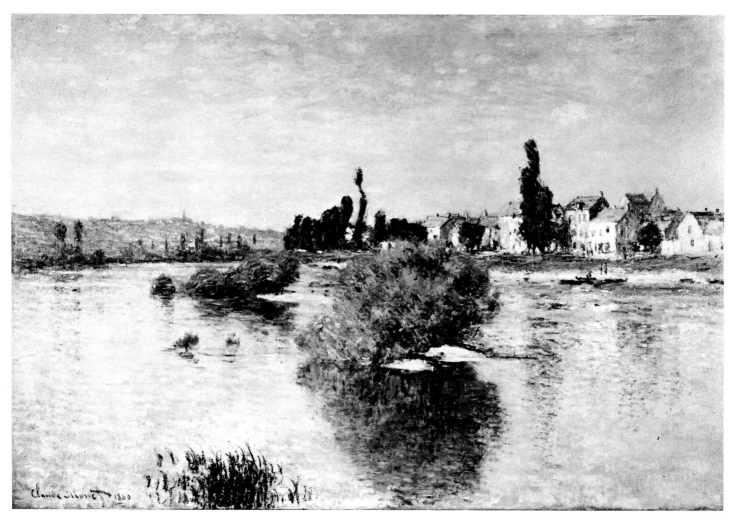

40. *The Seine at Lavacourt*. 1880.
Oil on canvas, 98.4 × 149.2 cm. (38¾ × 58¾ in.) Dallas, Museum of Fine Arts, Munger Fund Purchase

a little later in the year. Monet himself considered the work shown at the Salon to be somewhat 'bourgeois', no doubt implying that if not in itself a compromise, the painting had for a subject a motif susceptible to a calm and gentle composition and did not provoke that degree of colouristic emphasis which for him was 'true' but which to many represented eccentric extremism. A third river scene (Plate 42), one of the many painted that year, is smaller. Intended for closer viewing, it is more 'finished' in a conventional sense.

Such differing works are still capable of eliciting the range of response that they did at the time, and widely differing reactions are even more likely to be aroused when works from different periods of Monet's career are considered. Those of the 1870s are easily seen to be different in kind, if not in quality, from those of the 1880s, some of whose products moved Lionello Venturi to speak of 'integral Fauvism'. It is not always easy even today to reconcile a taste for the works of one phase with an enthusiasm for those of another, and this has something to do with our habits as spectators. If we are accustomed, when looking

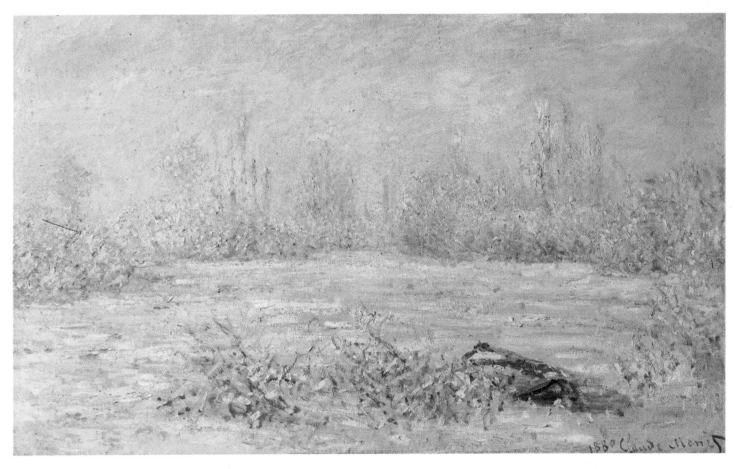

41. *The Frost*. 1880. Oil on canvas, 61 × 100 cm. (24 × 39½ in.) Paris, Louvre, Jeu de Paume

at a painting, to make a visual compilation of its parts, we are more likely to be drawn to the attractive little painting in Washington than to enjoy the more synthetic view of Lavacourt. The latter requires to be taken as a whole; 'bourgeois' or not, it represents the growing tendency in Monet's art simultaneously to stress the atmospheric 'envelope', as he was to call it, and to function in a decorative manner. The decorative qualities could work in unison with the atmospheric, and both contributed to an embrace, an emotional involvement.

Arsène Houssaye, the critic who had purchased the memorable *Camille* of 1866, wrote of Monet and Renoir as representatives of the school of 'Nature for Nature's Sake', as distinct from 'Art for Art's Sake' with its normative and primarily figure-based ideal of

beauty, a beauty which was also dispassionate. In thus categorizing Monet's work, Houssaye took a first step toward the implicitly romantic interpretation of the novelist J.-K. Huysmans. Huysmans, who had earlier been of the positivist frame of mind that could attribute the Impressionists' colour vision to pathological ophthalmic states, spoke in 1882 not only of the Truth in Monet's marine paintings but also of the 'intense melancholy' induced by his ice-floes. These remarks accurately reflect the direction in which Monet's particular notion of 'progress' was leading him. Pissarro himself came to distinguish between 'romantic' and 'scientific' Impressionism and, after his experiments of the eighties, to reaffirm the value of the former, of which Monet, with his energetic brushwork and colour alone, was surely the most distinctive representative. It is

42. *Banks of the Seine, Vétheuil.* 1880.
Oil on canvas, 73.3 × 100.6 cm. (28⅞ × 39⅝ in.) Washington, National Gallery of Art, Chester Dale Collection

not surprising that certain Symbolists, in spite of being polemically opposed to what they considered to be a soul-less Naturalism (of which Impressionism was merely a variety), were able to admire the later works of Monet, which seemed indeed to have successfully reconciled Nature and Art.

The 'poetry' discovered in Monet's works was not necessarily only a matter of mood evoked by colour and atmosphere. In 1885 Mallarmé published 'Le Nénuphar Blanc' in *L'Art et la Mode*, a journal managed and edited by Monet's patron Hoschedé. It seems surprising in retrospect that it was not this but another of his prose-poems for which Mallarmé was to ask Monet to provide an illustration, though the pervasive femininity of theme and of mood in Mallarmé's lines are surely evoked by a painting like *Boating on the Epte* (Plate 45), where two of Hoschedé's daughters, soon to become the painter's step-daughters, drift gently by. But whatever its evocative powers, it is wholly characteristic of Monet that in this, as in a companion painting (Plate 46), he should have consciously concerned himself only with a problem of representation and allowed the poetry to fend for itself, whereas a Symbolist would have looked for

51

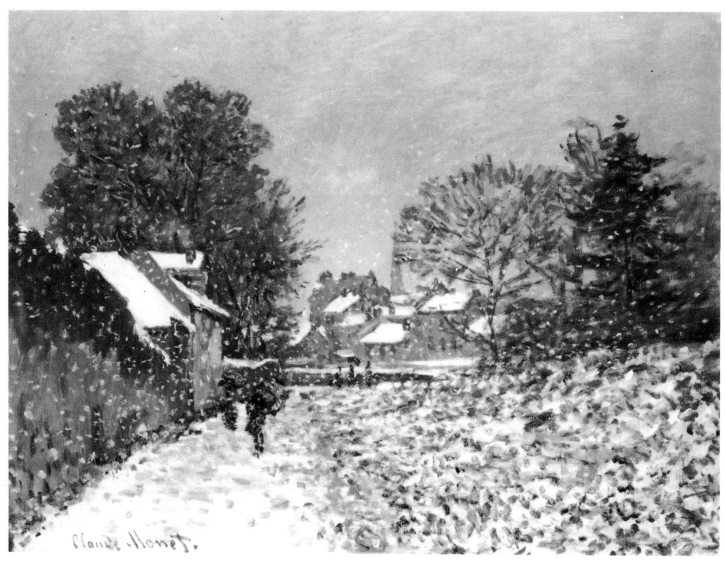

43. *Snow at Argenteuil*. 1874.
Oil on canvas, 57 × 74 cm. (22½ × 29⅛ in.) Boston, Museum of Fine Arts, Bequest of Anna Perkins Rogers

ways of manufacturing it. He spoke of the reeds below the surface of the water as 'things impossible to do'. He clearly spoke with some pride, for it was the technical challenge of rendering both the sense of surface and the reeds waving beneath it that occupied him as a test of his skills.

Snow-scenes were scarcely less fascinating. None of the Impressionists showed as much interest in them as did Monet. In 1867 his muffled figure was seen at work in the snow in the countryside near Le Havre. 'Art has its brave soldiers,' commented the observer. In

1886 Durand-Ruel described Monet as the 'man of the sun', but the painter, then at work at Belle-Ile on a particularly stormy group of marine paintings, which sometimes required him to stabilize his easel with heavy weights, protested that 'one mustn't play on a single note.' In 1890 he was looking forward to the arrival of the snow so that some of his *Haystacks* might be painted under its cover. He promised his dealer excellent results (Plate 56). In 1895, on a visit to Norway, he was obviously pleased to be able to tell Geffroy that he had been working in the endlessly

52

falling snow, while in December 1896 he was disappointed that none had fallen at Giverny: 'I have been able to make no wintry scenes.'

These scenes themselves were far from 'playing on a single note'. In his *Snow at Argenteuil* (Plate 43) Monet showed the feathery flakes drifting down, as the Dutch seventeenth-century painters had occasionally done before. With its broadly brushed and almost, but not quite undifferentiated sky and soft snowfall, the painting seems almost as evocative of silence as it is of the purely visual aspect of the scene. *Train in the Snow* (Plate 44) was a canvas which afforded Monet the dubious pleasure of having to arbitrate between rival purchasers. Although it was painted only a few yards away from the scene depicted in the previous canvas, it has a very different

44. *Train in the Snow*. 1875. Oil on canvas, 59 × 78 cm. (23¼ × 30¾ in.) Paris, Musée Marmottan

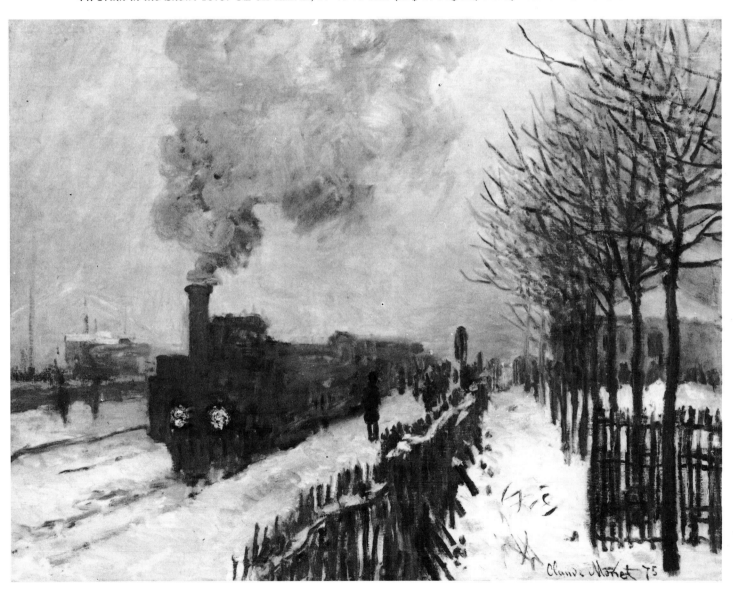

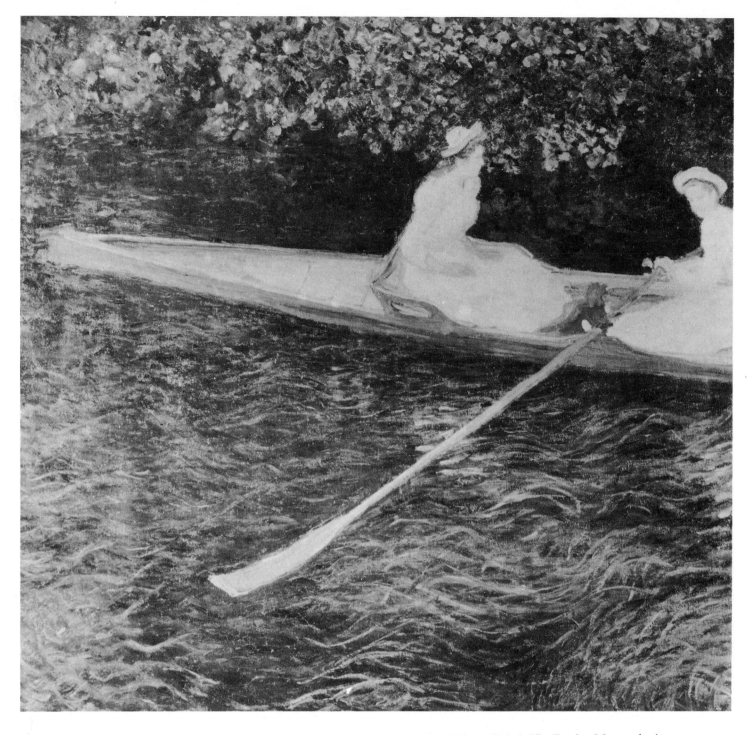

45. *Boating on the Epte*. 1887? Oil on canvas, 132 × 145 cm. (42½ × 57 in.) São Paulo, Museu de Arte

character, due not only to the 'modernity' of its subject, but also to the variation of tone and definition between near and far. This quality is accentuated by the steep perspective and, above all, by the contrast between the heavily impasted lamps—Monet was trying to suggest the aura surrounding them in a somewhat murky atmosphere—and the fluid handling elsewhere. There are similarities between Monet's approach in this painting and in his

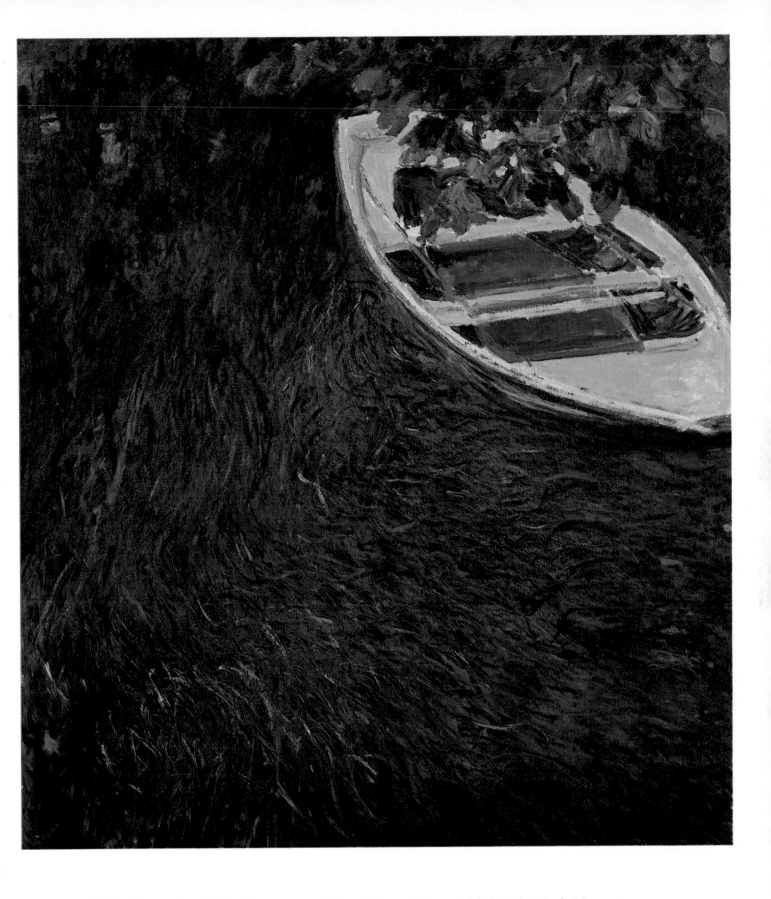

46. *The Boat*. About 1887. Oil on canvas, 146 × 133 cm. (57½ × 52⅜ in.) Paris, Musée Marmottan

Impression, Sunrise, but the earlier work still betrays a lack of confidence in assimilating the current notion of the 'sketch' to a new, phenomenological notion of what could constitute a 'finished work' needing no apology for itself. With *Train in the Snow*, however, the artist's assurance is no longer in doubt, especially in the configuration of the smoke rising above the stationary monster, with its suggestion of 'instantaneity'.

'Instantaneity' was a term Monet himself was employing by the time he painted his *Haystacks* in the 1890s. He used it to describe not any *a priori* application of a principle of artistic vision, but the necessary dependence of that vision on circumstances prone to rapid variation around the motif itself. Yet it must be admitted that in the painting here illustrated Monet accentuated the blueness of shadow—that most typical of all attributes of the Impressionist colour-vision—to a degree which suggests that the actual process of seeing was subject to modification, or exaggeration, by long-acquired habits of sight. It seems to exemplify what he meant when he once said that 'one is not an artist unless one carries the painting in one's head before executing it.' Such a remark confirms our feeling that the later works grew progressively less analytical and more synthetic and aware of the canvas as an independent organism. Monet's need to familiarize himself thoroughly with a new place before he could hope to do good work there represents one side of this coin. It would only be on his return *next* year, he wrote from Venice in 1908, that he would be able to produce good work. One of his requirements was a planned palette, but on the other hand any tendency to *impose* a vision was balanced by another aspect of Monet's working method. When he was painting his 'series', his step-daughter Blanche Hoschedé would fill a wheelbarrow with canvases and trundle it after the painter over the fields, so that when

conditions over the haystacks varied from one half-hour to the next he might take up another canvas, whether already begun in approximate conformity with the new circumstances or as yet untouched. In London he worked in his room at the Savoy Hotel surrounded by up to 100 canvases, in the best of which he was wholly successful in reconciling an analytic eye with a synthetic vision.

Snow at Argenteuil captures its motif so effectively that it stimulates us to imagine the muffled quiet of such scenes. When Monet exhibited eight of his views of the *Gare Saint-Lazare* (Plates 47, 48) at the third Impressionist Exhibition in 1877, some critics were moved to suggest that in these works the painter had managed to evoke the ugly sound of shunting locomotives. Such remarks, even if frivolously meant, can now only be seen as flattering indications of an artistic power which could pass beyond the merely visual to the synaesthetic. Monet was above all a pastoral painter and a painter of the sea, and he did not return to such specifically modern urban themes after this time. His later works have tended to provoke comparison with the music of Debussy, certainly not with Futurist 'noise-machines'. But whatever the genre in which he worked, the intensity of experience offered by Monet's paintings is such that the attentive spectator seems to integrate even these less decorative works into his experience of life itself.

'Intensity', a focusing of experience, seems the best word to characterize Monet's work of the 1880s. One means towards this intensity was a feeling for composition which is not always merely neutral, but can seem to come close to our normal understanding of the word 'design'. Another was a feeling for colour which reached in this decade a boldness greater than at any other time in his career. It provoked Degas one day to report that the weather was fine but more 'Monet' than his

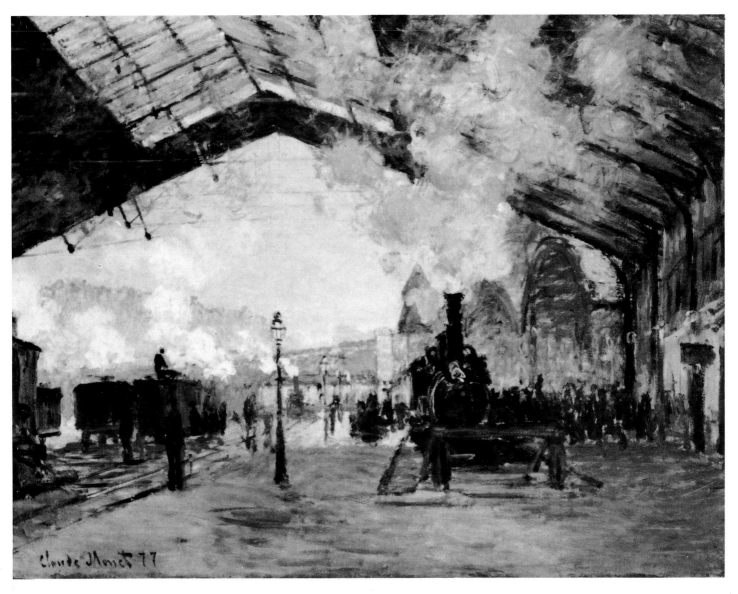

47. *Gare Saint-Lazare*. 1877. Oil on canvas, 59.7 × 80 cm. (23½ × 31½ in.) Chicago, Art Institute

eyes could bear. The same vein of Degas's wit, flattering enough to an artist concerned above all with the 'Truth', was indulged when he said in front of a group of Monet's landscapes: 'I don't like draughts.'

The composition of Monet's paintings was seldom a matter of very elaborate planning and manufacture, but it was never absolutely direct and unconsidered. Although the appli-cation of paint to canvas could be direct in the sense that there was little or no underdrawing, preparatory drawings for many paintings exist. He was often especially concerned with the 'framing' of the natural scene. The *Cliffs at Etretat* (Plate 49)—painted at the Normandy resort where Monet often worked—presents this picturesque motif with the naivety of a picture postcard, and the 'framing' is neither

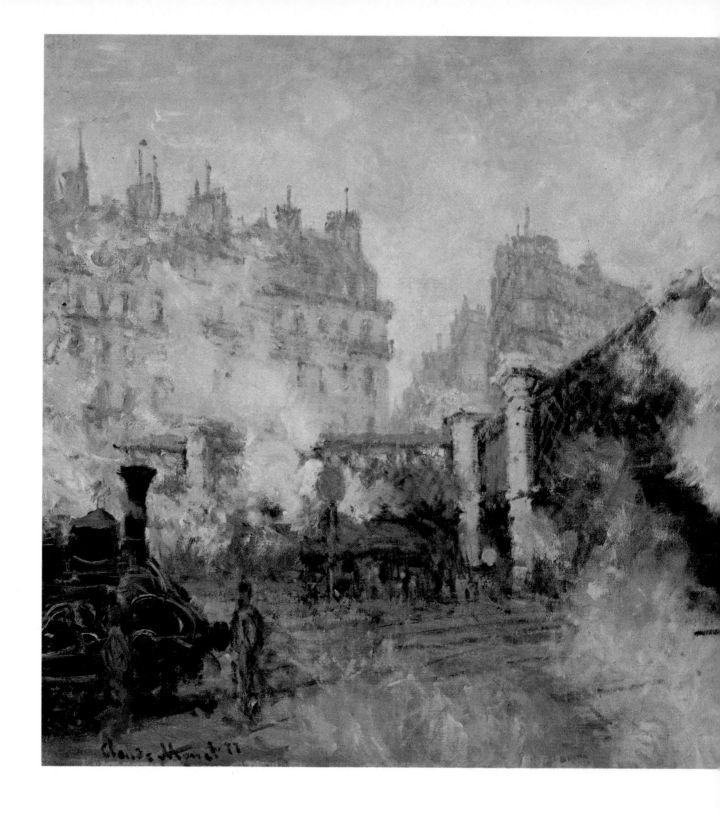

more nor less important than that of such a photograph. But in other paintings made there (Plate 51) he sometimes closed in on the famous arches, the 'gates', in the cliffs in such a way as to produce less stable but far more dramatic scenes, where the textured surface of the rocks was of as much interest as their configuration. Such a relationship between composition and painterly values is visible in a comparison between *The Cliff Walk* of 1882

48. *Le Pont de l'Europe, Gare Saint-Lazare.* 1877. Oil on canvas, 64 × 81 cm. (25¼ × 31⅞ in.) Paris, Musée Marmottan

width of the canvas, imposes a stability which is less typical of Monet's work in this decade than it was of the structural logic favoured by the Neo-Impressionists. The little figures, perhaps added later, are very carefully positioned, so that a tiny parasol interrupts the sky-line without really disturbing it. The delicate modulations of sky, sea and vegetation seem to take their cue from this imposed structure, which dominates the rhythmic irregularity of the cliff-edge, and to read primarily as broad areas. In the painting of Bordighera, on the other hand, by placing himself so close to the trees, Monet was certainly able to convey a characteristic aspect of the physical features of this part of the world and to suggest a 'design'; but above all he makes us very conscious of the greens and reds which animate the otherwise appropriately desiccated palette, in a way that suggests a certain subjective element in his vision, whatever rationale may have been applicable. No doubt it was this sort of palette, as much as the broken brushwork, that obliged Durand-Ruel later in the same year to vex Monet's patience once again with the question of 'finish'. The conventional taste of a public, on whose behalf the dealer was to some extent bound to speak, would surely have preferred paintings in which the artist smoothly blended his colours and offered a blander and more prefabricated synthesis—such as he was indeed later to offer.

'Truth' and 'intensity' came in the south to seem identical to Monet in a way which is not in principle different from his previous practice, but which in those particular surroundings was bound to appear so. He was himself afraid that the Mediterranean views would seem exaggerated to many, though he felt that what he could achieve fell well below the dazzling reality. Unlike Gauguin and van Gogh a little later, he did not believe in exaggeration as an artistic principle in its own right. Van Gogh,

(Plate 50) and a view of Bordighera (Plate 3), made two years later on Monet's second visit to the Mediterranean. In the earlier of these paintings a precisely chosen viewpoint, which allows the horizon to run almost the whole

however, particularly admired Monet's courage as a colourist, and regarded him as the great precursor of a new school of colourism to be established in the south of France. Monet's stimulating success can be seen in paintings like those of *Le Cap Martin* (Plate 52) and *Ventimiglia* (Plate 53). The earlier of these paintings is composed of delicate marks, which conform in general to the primary complementary colour pairs red–green, yellow–violet and orange–blue. In addition there are white touches (some actually illustrative of tree-trunks) indicating the presence of the strong light on which this powerful, but not unduly systematized colourism depends. In fact the surprising possibilities of a quite limited palette are already evident in this gem-like painting. 'Gem-like' was Monet's own word to describe the effects he found in the south, and it is not surprising that in 1886 Boudin found Monet's paintings so 'daring', 'vibrant' and 'intense' that it was impossible to

49. *Cliffs at Etretat.* 1883. Oil on canvas, 64.9 ×81.1 cm. (25½ × 31⅞ in.)
Williamstown, Massachusetts, Sterling and Francine Clark Art Institute

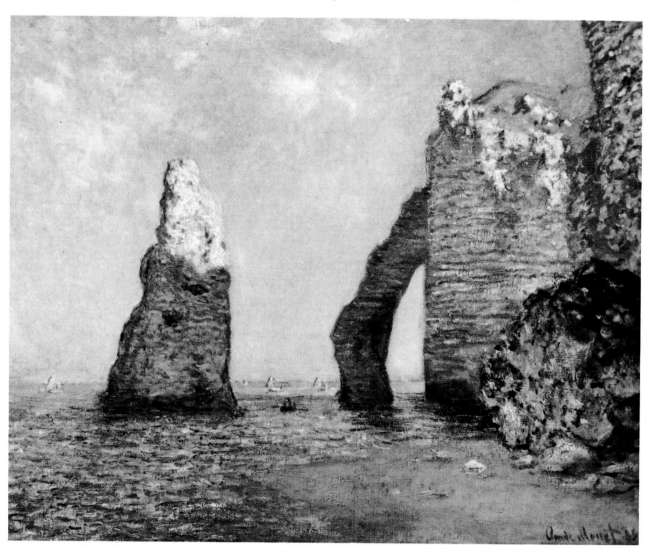

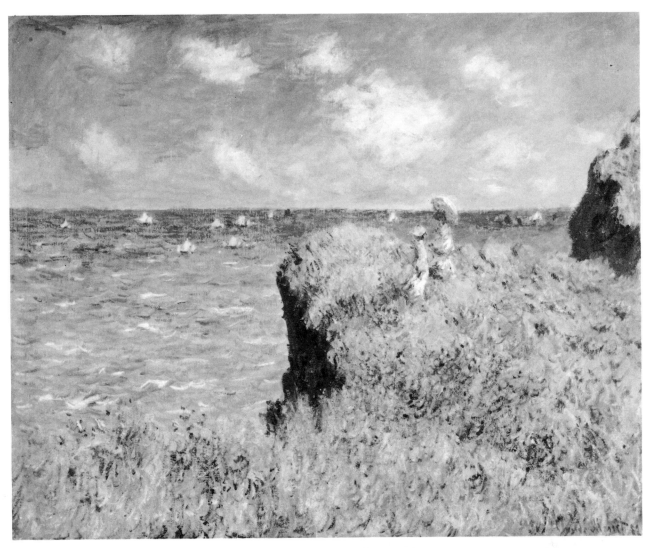

50. *The Cliff Walk, Etretat.* 1882. Oil on canvas, 65.4 × 81.9 cm. (25¾ × 32¼ in.) Chicago, Art Institute

look at anything else afterwards.

In the view of *Ventimiglia*, Monet adopted a favourite practice, that of setting an animated strip of vegetation before a distant and more broadly painted view. The effect here is not unlike that achieved by Cézanne in some of his paintings of similar motifs, but there is also a strong feeling of the rapidity of Monet's

51. *The Manneporte, Etretat.* 1886. Oil on canvas, 81.3 × 65.4 cm. (32 × 25¾ in.) New York, Metropolitan Museum of Art

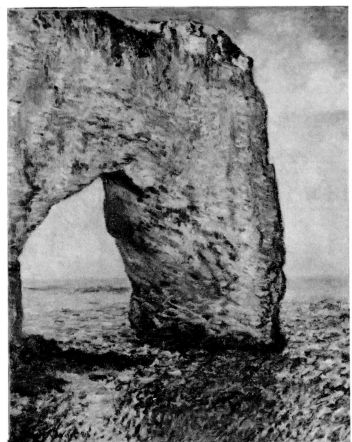

execution—not only in the painterly texture but also in the way that some sea blues find a place among the warmer tones of the flowering shrubs, and some leafy greens appear as gradations on the sea. Monet was sometimes accused by his critics of making mere hasty approximations, and the reasons for such judgements are apparent in such a painting, which certainly contrasts with Cézanne's painstaking methods. Both artists sought a sense of unity, but Monet's was much more purely optical than Cézanne's. Cézanne considered Monet 'the strongest of us all', but Monet later found it impossible to work in the

52. *Le Cap Martin*. 1883. Oil on canvas, 65.5 × 82 cm. (25¾ × 32¼ in.) London, Collection Cyril Humphris

53. *Ventimiglia*. 1884. Oil on canvas, 65 × 91.7 cm. (25½ × 36 in.) Glasgow, Art Gallery

company of the Cézannes he owned, and his wife would turn them to the wall. Each inspired in the other a great humility.

In his portraits Monet showed himself more sensitive, if less monumental, than the dispassionate Cézanne. The 'curious sketch', as he called it with some pride, of a pastry-cook at Pourville (Plate 54), is a real characteriza-tion, as is the portrait of a Belle-Ile fisherman (Plate 55). Such works may owe their existence chiefly to the inclement weather that was a constant complaint in his letters, but M. Paul's joviality and Poly's embarrassment at sitting are both humanely rendered. The erstwhile caricaturist here found real, not merely typological, persons.

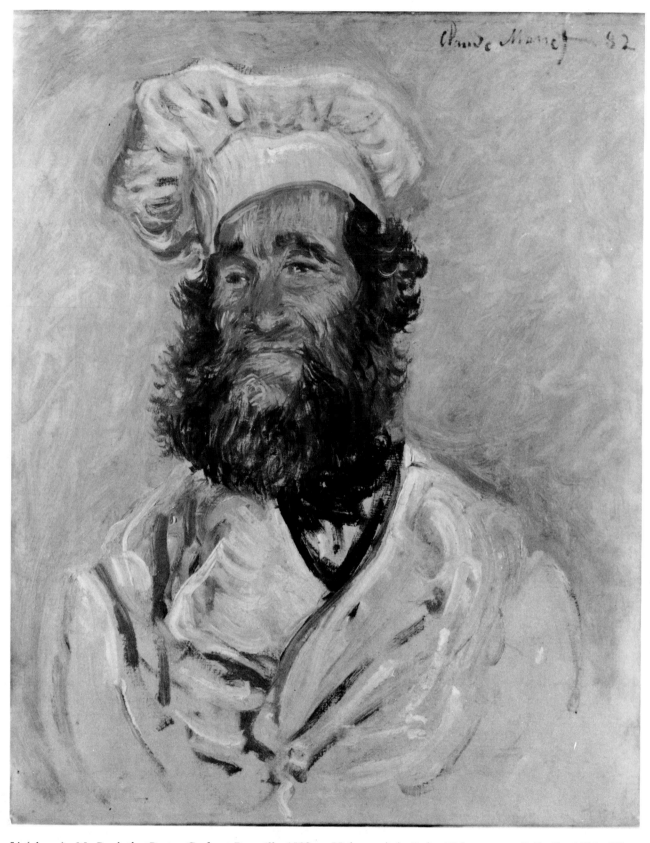

54 (above). *M. Paul, the Pastry Cook at Pourville*. 1882. Oil on canvas, 64 × 51 cm. (25¼ × 20 in.) Vienna, Kunsthistorisches Museum

55 (opposite). *Poly, Fisherman at Belle-Ile*. 1886. Oil on canvas, 74 × 53 cm. (29⅛ × 20⅞ in.) Paris, Musée Marmottan

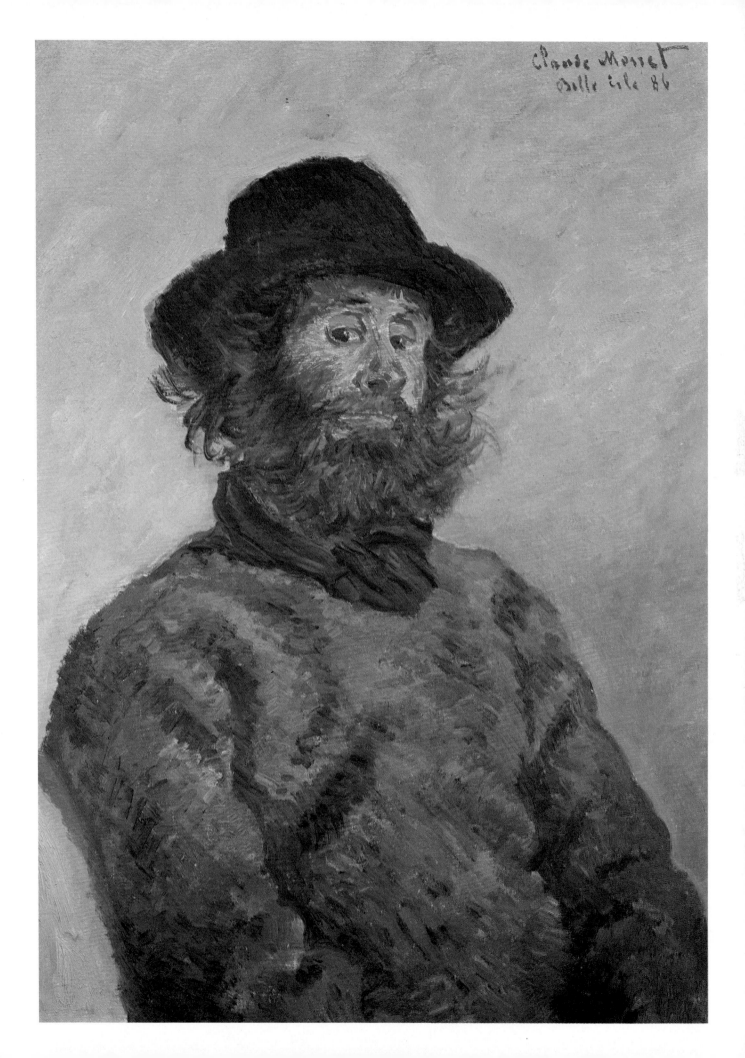

Late in 1892 Monet joined the list of artists under consideration as candidates to continue the decoration of the new Paris Hôtel de Ville (Town Hall). His reputation as a 'decorator' had been much enhanced by the first exhibitions of his true 'series' paintings: in 1891 of fifteen of his *Haystacks* (see Plates 56, 57), and in 1892 of fifteen *Poplars on the Epte* (see Plates 58, 59). Monet was not asked to work for the Town Hall, although already in 1891 Octave Mirbeau had felt able to compare him with Puvis de Chavannes, the most 'professional' decorator of public buildings of the time, who contributed several works to that building. Mirbeau found that their very different manners were both supremely 'poetic'. Monet, the analyst of light, could thus be equated with an artist who spoke of his concern to achieve synthesis and harmony above all, and had become a cynosure to the Symbolists. The series paintings seemed, with their harmony derived from nature, to transcend the earlier naturalism and discredit the narrow-mindedness of polemical battles between the schools. This is indeed implied by the famous story told by Kandinsky in his *Reminiscences*; on his first encounter with one of the *Haystacks*, he failed to recognize any subject; this experience contributed to his own development of an expressive, non-objective art.

The evocative quality of the series paintings was much enhanced by their presentation in groups, for while Monet could argue that his concern with different atmospheric effects was thus made plain, they tended to offer an environment, an enveloping experience different in kind from that deriving from his concern with the atmospheric 'envelope' itself. The logical outcome was that apotheosis of 'mood' which constitutes the two oval rooms in the Orangerie. This was indeed what Gustave Geffroy called 'sensation transformed into reverie'.

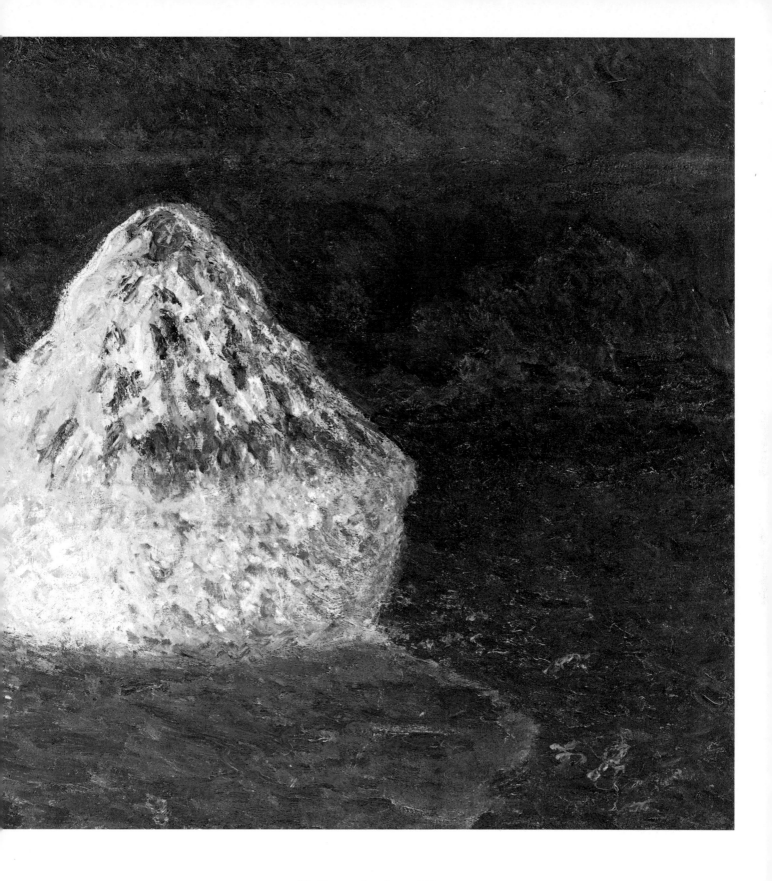

56. *Haystacks, Snow*. 1891.
Oil on canvas, 64.8 × 92.1 cm. (25½ × 36¼ in.) Edinburgh, National Gallery of Scotland

But Monet's paintings are more than mere colour-arrangements on a flat surface. The 'water-landscapes' can themselves achieve a remarkable sense of space, of movement in depth (Plate 62). In a way this makes them more stimulating to the viewer than their more conventionally planned predecessors, like the series showing the Japanese Bridge Monet built over his water garden (Plate 63). The notion that Monet deliberately sought out 'difficult' motifs has not always been accepted, but it is consistent with his frame of mind throughout his career that he should have taken pride in overcoming the spatial challenge of the *Nymphéas*. Challenges of different kinds were surely what he had in mind when in 1885 he wrote of his wish to exhibit, in a forthcoming exhibition in Brussels, five paintings in which he might show *himself* (*me montrer*) in different aspects. Skill in capturing the thing seen retained priority in his conscious thoughts over any more expressive ambitions.

By the time he painted his *Rouen Cathedral* series (Plate 60), twenty of which were exhibited in 1895, Monet was habitually completing his paintings at Giverny, with his numerous canvases as *aides-memoire* to help him reconstitute the various conditions under which the motif had been encountered. This was necessarily also the case with the views of London (Plates 33, 61), thirty-seven of which were shown in 1904, and those of Venice (Plate 65), seen in 1912. The decorative effect of the series, which must certainly have owed something to this less—or more—than empirical working method, was surely what encouraged Clemenceau to propose that the State should buy the whole exhibition of *Rouens* in order to prevent their dispersal. By categorizing these paintings in four sub-groups, a 'grey', 'white', 'rainbow-hued' (see Plate 60) and a 'blue', Clemenceau implied that for him, at least, the issue was more than the capture of various effects. Yet the apostle of painting

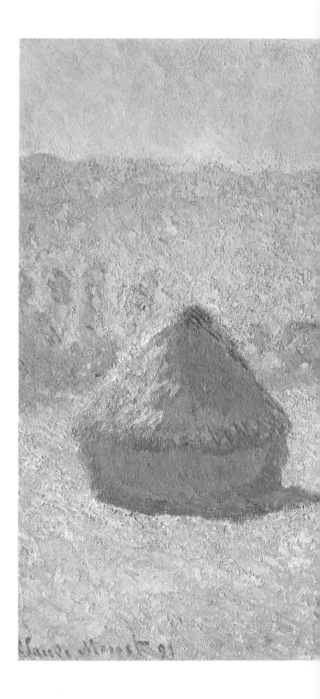

68

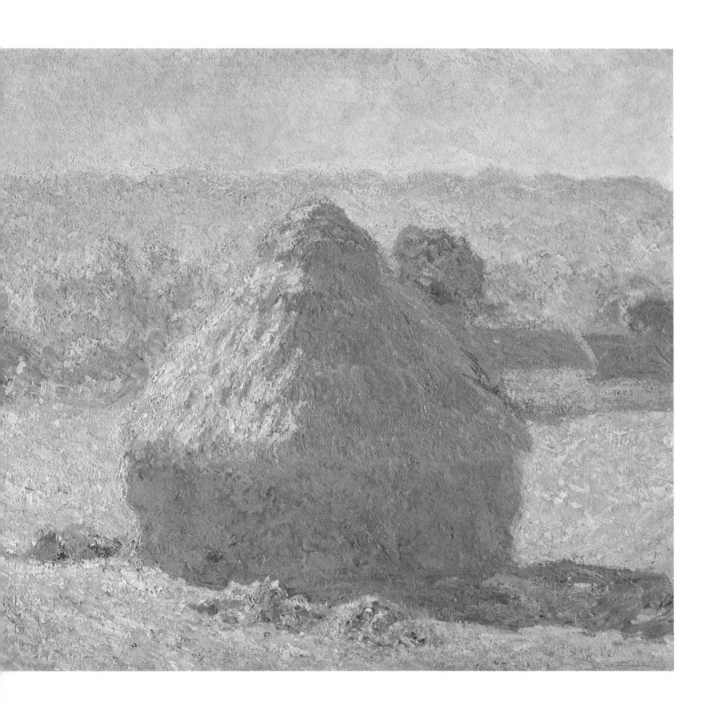

57. *Haystacks, Late Summer*. 1890–91. Oil on canvas, 60.5 × 100.5 cm. (23$\frac{7}{8}$ × 39$\frac{5}{8}$ in.) Paris, Louvre, Jeu de Paume

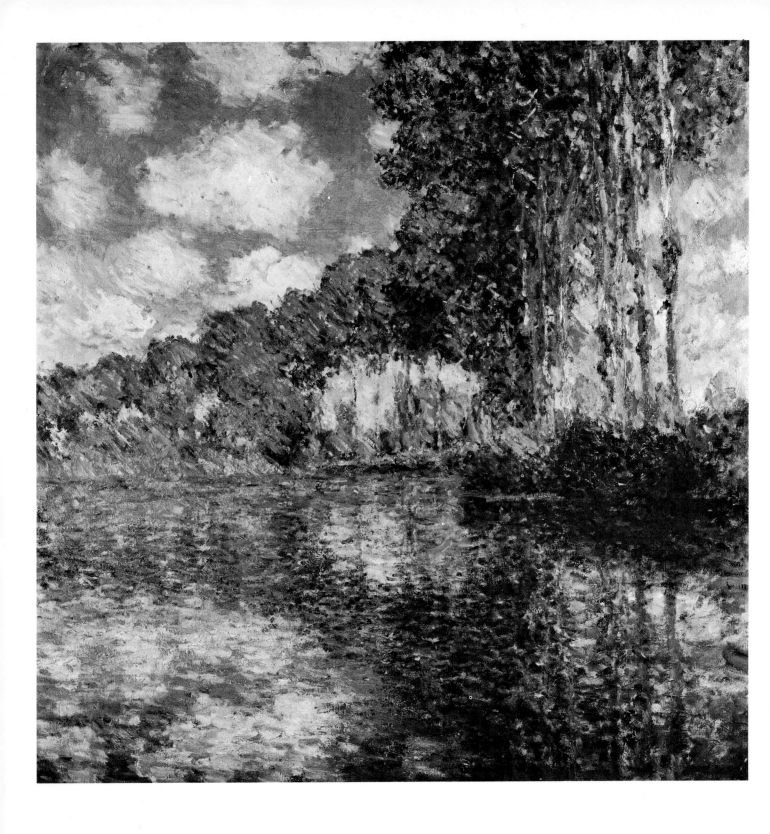

58 (above). *Poplars on the Epte*. 1891. Oil on canvas, 81.9 ×81.3 (32¼ × 32 in.) Edinburgh, National Gallery of Scotland.

59 (opposite). *Poplars, Wind Effect*. 1891. Oil on canvas, 100 × 73 cm. (39⅜ × 28¾ in.) Courtesy Durand-Ruel

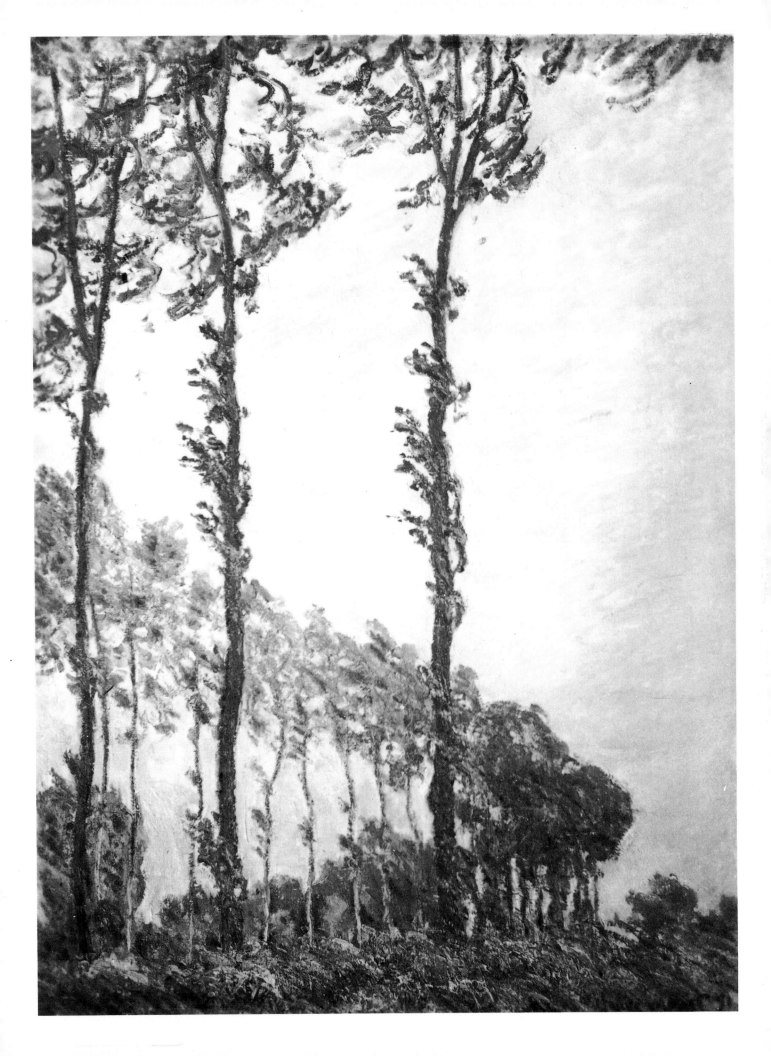

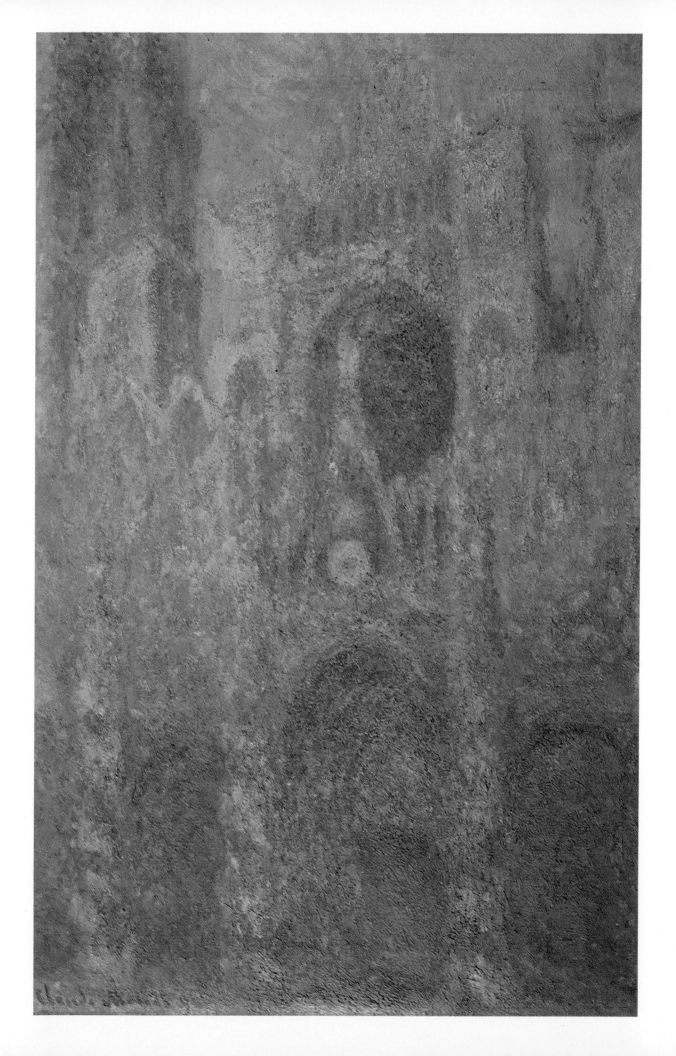

in the open air had previously denied using a studio at all. Only drawings, of which he made few enough, might sometimes be done indoors, especially when he was asked to make a reproduction of one of his paintings for a magazine or a catalogue.

The change in Monet's method, and in his art itself, is no doubt due in part to the eye-trouble which he first mentioned to Durand-Ruel in 1900 (though already in the 1860s he had once been advised to cease working out of doors until he had recovered from a bout of eye-strain). But not too much should be attributed to this factor, which led in 1923, three years before his death, to a successful operation for cataract. Earlier paintings in the late manner can be seen as a logical development from the practice of using a forceful, selective palette, which had been adopted in the 1880s. They are characterized by a colouristic extravagance, which is particularly evident in the independent works rather than the series paintings. The *Weeping Willow* (Plate 64) is a modest enough example of the often violent late work. But however reductive his method, the painter's aims were here no

60 (opposite). *Rouen Cathedral, Sunset*. 1894. Oil on canvas, 99 × 63.5 cm. (39 × 25 in.) Cardiff, National Museum of Wales

61 (below). *Waterloo Bridge, Cloudy Weather*. 1900. Oil on canvas, 63.5 × 92.7 cm. (25 × 36½ in.) Dublin, Courtesy of Hugh Lane Municipal Gallery of Modern Art

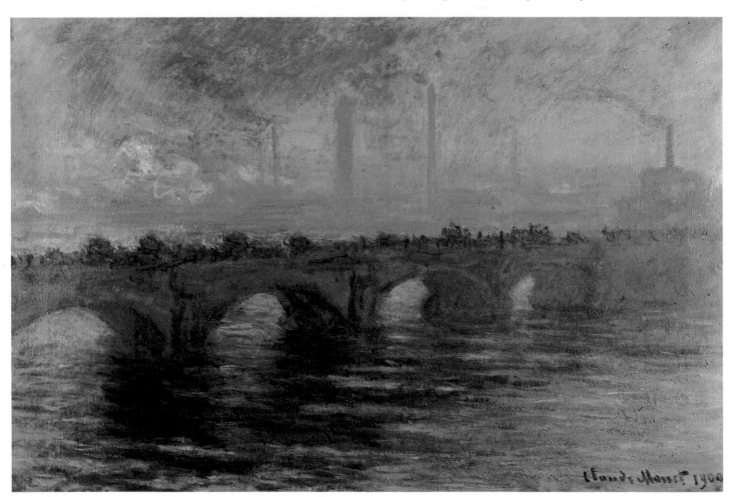

73

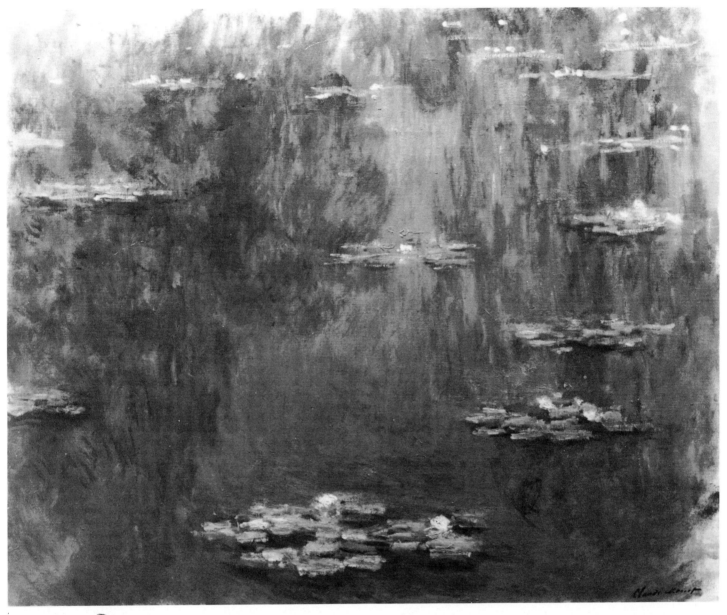

62. *Water-Lilies* (*Nymphéas*). 1905. Oil on canvas, 73 × 92 cm. (28¾ × 36¼ in.) Paris, Musée Marmottan

less 'naive' and 'sincere' (to employ two terms favoured in advanced art circles in the 1860s) than they had been at the beginning of his career.

When Degas, in the 1880s, categorized Monet's work as 'the art of a decorator, but ephemeral', Pissarro agreed. There was here an assumption that some stasis, some linearity, some feeling of permanence such as is to be found in the work of Puvis de Chavannes—and of Degas himself—was the essential attribute of a decorative art. Monet himself was for a long time uncertain as to what, precisely, constituted a 'decorative' art—

74

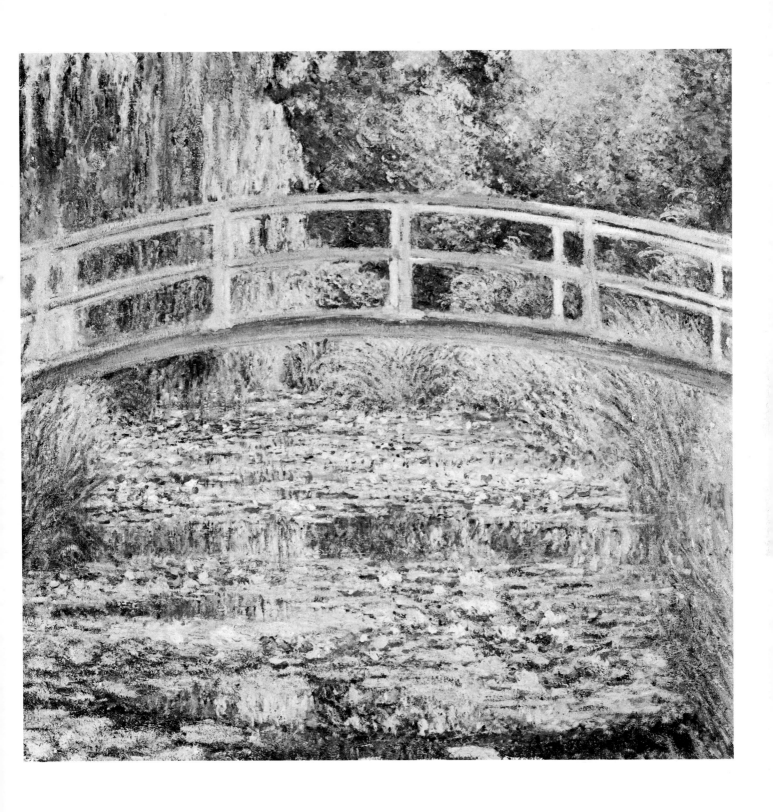

63. *The Water-Lily Pond.* 1899. Oil on canvas, 89 × 93 cm. (35 × 36⅝ in.) London, National Gallery

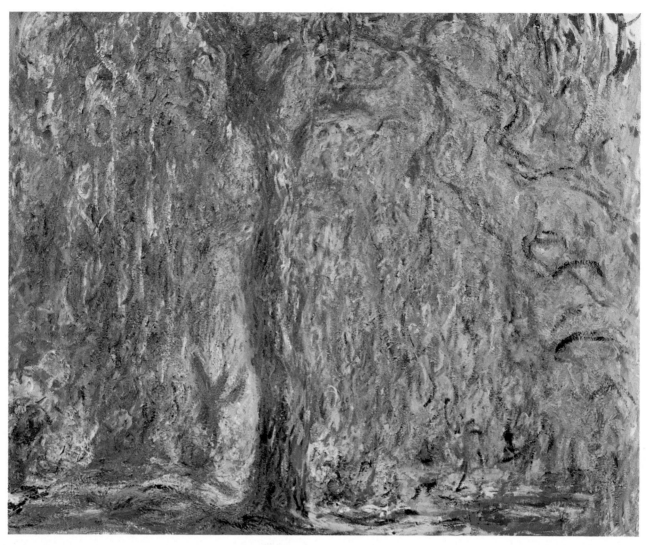

64. *Weeping Willow*. About 1919. Oil on canvas, 100 × 120 cm. (39⅜ × 47¼ in.) Paris, Musée Marmottan

though hardly more uncertain than the confusing theories current at the time. In 1884 he produced a 'panel' for Berthe Morisot which was intended specifically as a decoration, and was at one moment prepared to let Berthe choose for herself anything from his recent production that might 'seem suitable for a decoration'. This can be taken to imply that he himself was unable to make a clear aesthetic distinction in this matter. 'One doesn't make paintings out of theories,' he once said. The

Morisot commission was not his first, however, for in the previous year he produced six such panels for Durand-Ruel's private home (and earlier he had made four for Hoschedé).

But whatever the aesthetic issues, there was one kind of painting, the still-life, which could almost *ipso facto* be thought decorative. In his still-lifes Monet was able to combine his developing manner with a traditionally decorative subject-matter without compromising either. The pragmatic reason for painting such

works was that they could sometimes be sold for prices higher than those attained by his landscapes. The early *Trophies of the Chase* (Plate 66) is clearly addressed to a particular market. One of Hoschedé's four panels showed him with his friends on a shoot. This early painting is very far from 'ephemeral' in the sense meant by Degas when speaking of later works. It is a more deliberately, even academically structured painting than anything Monet painted later, far more than anything comparable made by Boudin. This sort of ordered informality is still present, though in a much less obtrusive way, in the little painting of *Red Mullets* (Plate 67) made nearly a decade later, but any genre or implied domestic narrative element has been dismissed from this oddly Cézannesque little canvas. Indeed the choice of subject was surely now made for much more painterly reasons, and this was also the case when he painted pheasants another decade later. Whatever their thematic appeal, the true

65. *San Giorgio Maggiore, Twilight.* 1908–12.
Oil on canvas, 63.5 × 89 cm. (25 × 35 in.) Cardiff, National Museum of Wales

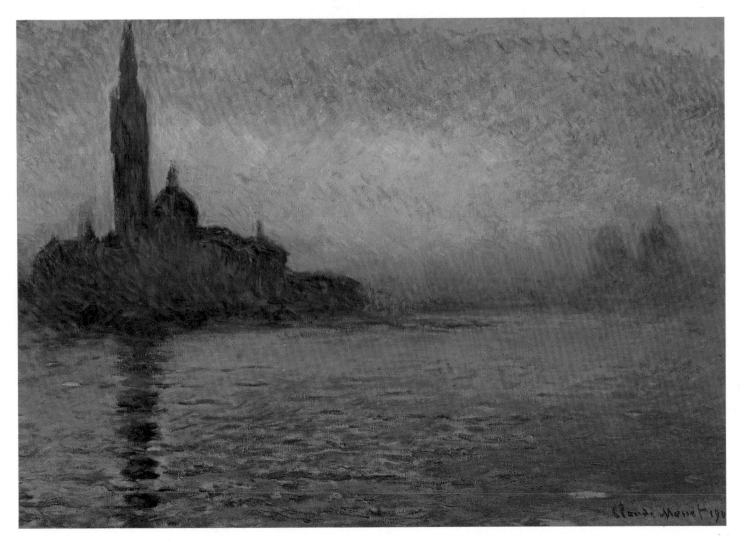

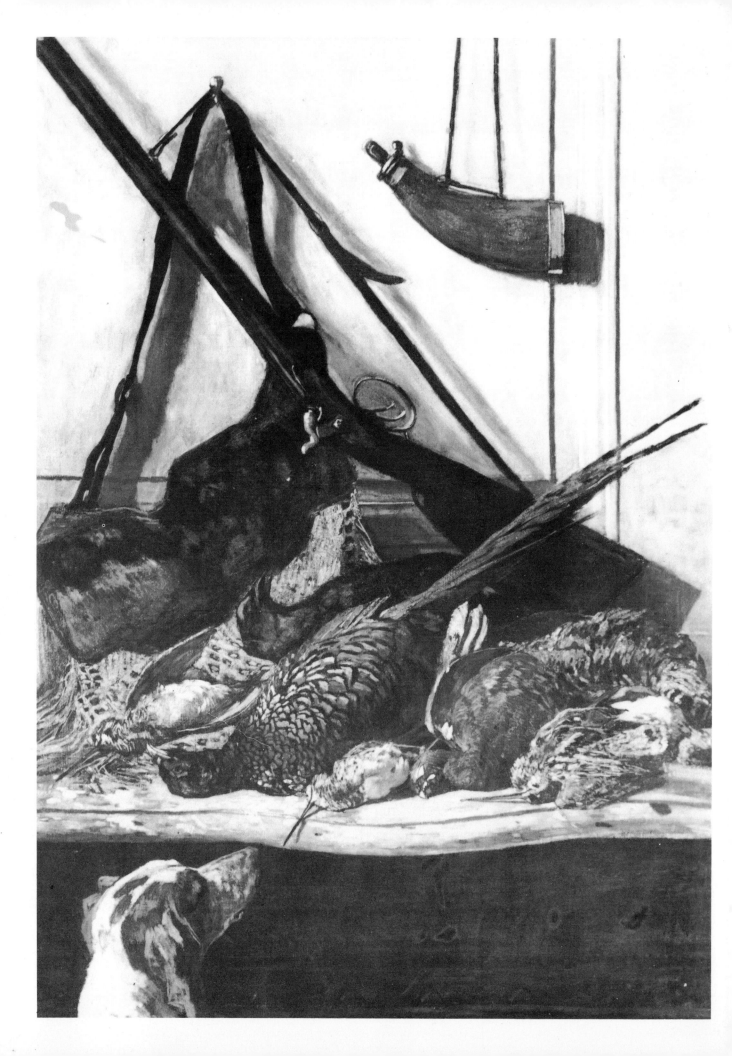

subject of such works is the texture and luminosity of scale and feather.

At the beginning of his fifth decade, a time of change in his art and also in his life (particularly concerning Camille's death and his ever more intimate liaison with Alice Hoschedé), Monet made several flower-pieces. They seem to embody many of the finest qualities of the works of his whole mature career. In paintings like these (Plates 68, 69), working in the most decorative of all tradi-tional genres, he showed all his now sponta-neous skills, that sensibility, that sensitivity of response, which are the special justification of his wish to be considered self-taught. This was a unique sensitivity and it was so constantly alive that Monet even feared, at one moment, that he risked becoming a 'painting machine'. Work itself was salvation and a balm to shattered morale, though often also its cause; hence the need to continue working indoors when conditions outside made that impossible.

66 (opposite). *Trophies of the Chase*. 1862. Oil on canvas, 104 × 75 cm. (41 ×29½ in.) Paris, Louvre, Jeu de Paume

67 (below). *Red Mullets*. 1869. Oil on canvas, 35.5 × 50 cm. (14 × 21⅝ in.) Cambridge, Massachusetts, Fogg Art Museum

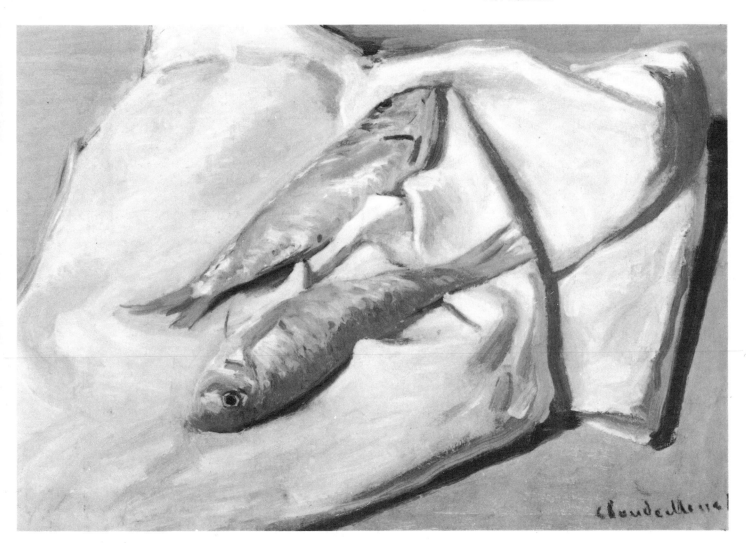

But in the flower-pieces Monet's response to beauty almost literally enabled him to identify Nature with Art. His eye found interest not only in a picturesque motif but far more in the minute variations on colour and tone, of light and shade, all now subsumed under the all-important quality of colour. Here was the permanence of Art preying on the most ephemeral of Nature's objects. The flower beds tended by a small army of gardeners at Giverny could not aspire so high.

68. *A Vase of Flowers*. 1880. Oil on canvas, 100 × 81 cm. (39⅜ ×31⅞ in.) London, Courtauld Institute Galleries

69. *Chrysanthemums*. 1882. Oil on canvas, 100.3 × 81.9 cm. (39½ × 32¼ in.) New York, Metropolitan Mus. of Art

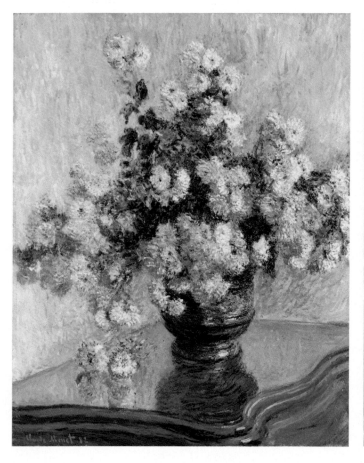

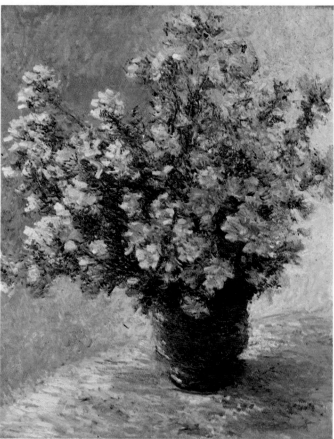